City on a Hill

City on a Hill
Twenty Years of Artists at Cortona

Georgia Museum of Art
The University of Georgia
Athens, Georgia

City on a Hill: Twenty Years of
Artists at Cortona
Georgia Museum of Art
The University of Georgia
March 25 - May 7, 1989

This exhibition and catalogue are
made possible with the generous
support of the Office of the Gover-
nor of Georgia, The University of
Georgia, and private contributors
to Friends of The University of
Georgia Studies Abroad Program.

Designed by Dianne Penny.
Typesetting and printing by The
University of Georgia Printing
Department.

In memory of

Angelo Moriconi, Mike Nicholson, and Yancey Robertson

Joe Frank Harris
Governor
State of Georgia

Georgia is proud and honored to exhibit this collection of art reflecting the close association between Georgia and the Tuscany region of Italy. The state of Georgia has had a long and cherished friendship with Italy, particularly Tuscany, with whom we have a sister-state relationship. This exhibition is an opportunity for us both to learn more about one another's regions and to establish even closer ties.

Georgia has been fortunate to have had many ties with Italy throughout our history. Georgia's city of Rome was named for Italy's renowned City of Seven Hills. More recently, our State Capitol dome in Atlanta was refurbished and laid in gold by Italian artists. The relationship is not, however, one-sided. Both cultures benefit from long-running cultural, educational, and economic exchanges. It was my pleasure to visit Italy on an economic development mission which I believe will prove to be important to our two countries in the years to come.

In this spirit, we take great pleasure to introduce this fine exhibition, recognizing that it is only one of many cultural exchanges that have developed and will continue to develop from our sister-state relationship with Tuscany.

Gianfranco Bartolini
President
Region of Tuscany
(translated by Aurelia Ghezzi)

Twenty years have passed since The University of Georgia came to Cortona to hold its summer courses. In the beginning, some considered the decision to establish a studies abroad program in Cortona to be risky, but today that decision is confirmed in a well-established and mutually satisfying relationship. The choice made then was a daring one. The planners did not surrender to the easy temptation of identifying Florence with all of Tuscany. Instead they preferred to immerse the program in the variegated reality of a very rich region—like few others in Europe—made of cities, both large and small, all with a similar heritage of history, art, and culture.

Cortona is one of the proudest protagonists of this great municipal tradition, a bulwark of autonomy and liberty. And if

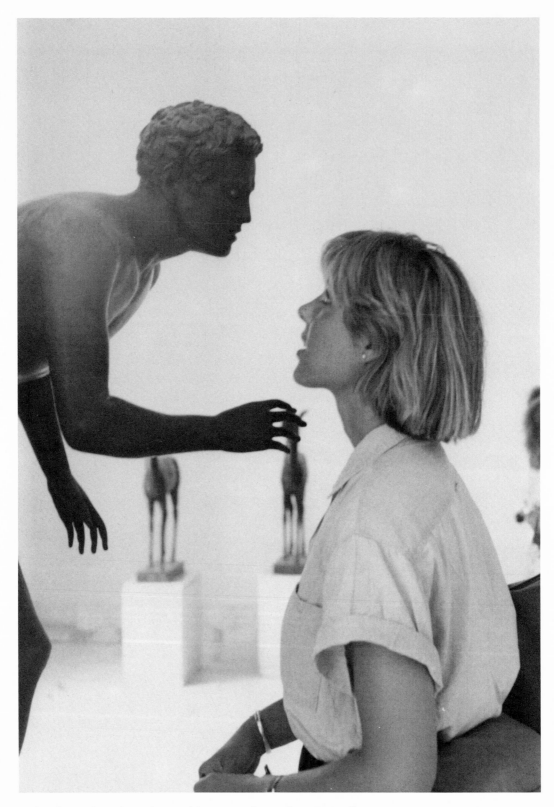

University of Georgia student and bronze sculpture from Pompeii
Museo Nazionale, Naples (photography by Mary Ruth Moore)

it is true that the proud independence of Tuscan cities may have caused them to degenerate into separatism, it is a consequence of the great love of its citizens for liberty —a feeling our American friends certainly can understand well. The University of Georgia chose to ally itself with this tradition. Today, it is harvesting the fruits.

Among the reasons The University of Georgia chose to become "related" to Tuscany was without a doubt the appreciation for the cosmopolitan tradition of our region. This tradition has marked the history of Tuscany, from the great explorers who first left for lands overseas, to the visitors who, on the Englishmen's footsteps, chose to retrace the fascinating artistic itinerary of our region, and, finally, to the Tuscan entrepreneurs who in the last twenty years have chosen to market their products in the United States. A very close relationship, therefore, made—as it should be—of common cultural as well as business interests.

Therefore it is with great pleasure that we recognize the celebration of the twentieth anniversary of this beautiful association between The University of Georgia and the city of Cortona. Such an association has not limited itself to words, but has produced the praiseworthy works that we admire today in this exhibition, reproduced in this catalogue. We express our compliments to the artists and our wish that our friends of The University of Georgia may produce still more work in the next twenty years.

Charles B. Knapp
President
The University of Georgia

Among the many prestigious academic areas within the complex structure of The University of Georgia, there is one which has established its reputation on foreign soil. This is the interdisciplinary Studies Abroad Program at Cortona, Italy. In the summer of 1989 it will begin its twentieth consecutive year of operation. Today it is one of the largest and most comprehensive studio art programs in Europe. More than 1,900 students have found their way up the mountain to this hill town in Tuscany, Cortona, where they have enjoyed an excellent educational experience in the program.

In recognition of this unsurpassed record of achievement and as an expression of gratitude to our Italian hosts, this special exhibition has been organized for the twentieth anniversary year. The interchange between our two cultures has created an atmosphere of understanding which will strengthen the bonds between our two countries. The University of Georgia can take

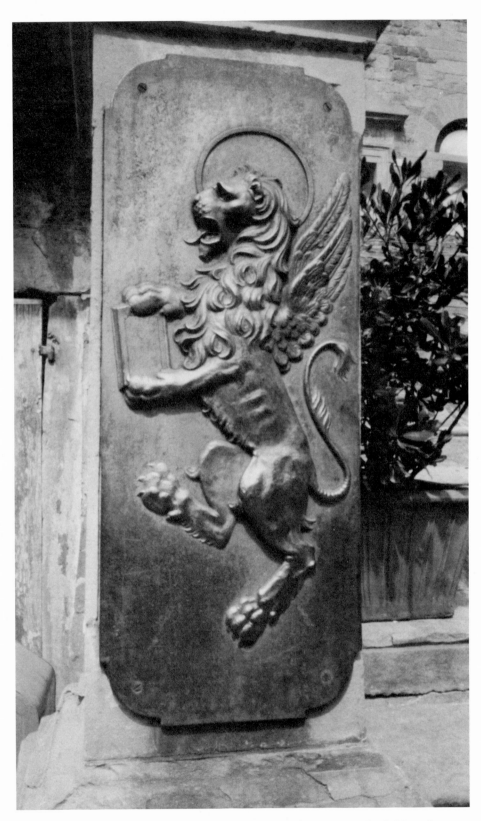

Bronze Griffin, Palazzo Comunale, Cortona (photography by Mary Ruth Moore)

pride in bringing together these important artists, while also furthering the close bonds between Italy and the United States. The special relationship enjoyed by The University of Georgia Studies Abroad Program and Cortona today has developed over the past two decades through the outstanding cooperation between our two peoples. Cortona's administrators and citizens have received us with warmth and enthusiasm. Their cooperation, friendship, and support have helped produce one of the finest studies abroad programs in the world.

The recognition of the participating faculty, artists-in-residence, and alumni of the Cortona program is tangible evidence of the physical and moral support given by our Italian hosts to the studies abroad effort. Last year my family and I experienced the unmatched beauty and hospitality of Cortona. We now feel that we are truly a part of the Cortona experience.

It gives me great pleasure and satisfaction to applaud the twentieth anniversary of the Cortona Studies Abroad Program, and to express my gratitude on behalf of The University of Georgia to all those who have made this outstanding relationship possible.

Italo Monacchini
Mayor
Cortona
(translated by Aurelia Ghezzi)

Cortona and The University of Georgia celebrate this year the twentieth anniversary of their cooperation, cultural relations, and the encounter that marked the beginning of a warm and lasting friendship. This friendship has developed not only between the individuals directly involved, but also between the municipalities of Cortona and Athens, between the region of Tuscany and the state of Georgia, and—most important—between the citizens and youths of different nationalities, cultures, and traditions.

Because the history of the past twenty years is so rich in events and exciting experiences, it is very hard to speak of this encounter of two cultures whose heritages are so different and yet so complementary. We cannot really talk of these years that saw a relationship of great vitality develop, or of the irreplaceable human, social, and cultural value. This relationship must be credited to the work of my predecessors: Halo Petrucci, Tito Barbini, and Ferruccio Fabilli on one side, and on the other side, University of Georgia presidents Fred Davison, Henry King Stanford, and Charles Knapp, as well as, of course, director and founder of the Cortona program, John D. Kehoe, and his assistant, Aurelia Ghezzi.

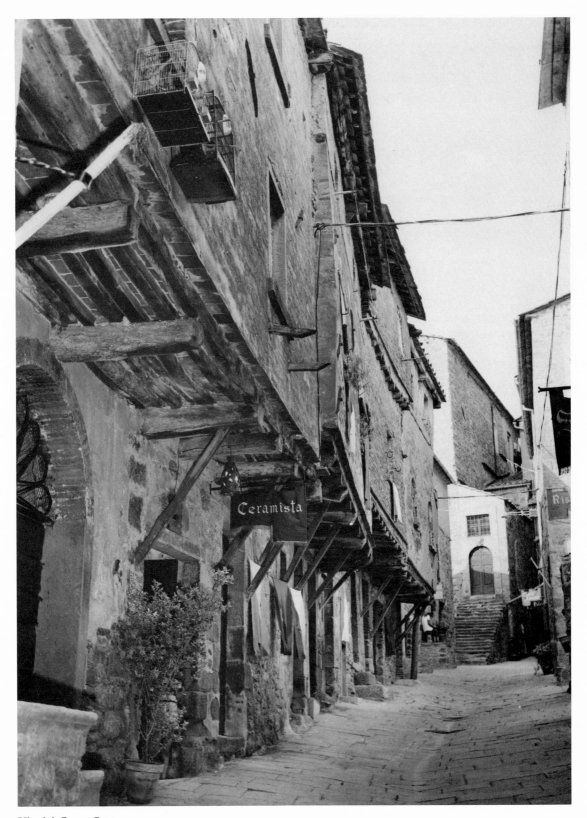

Via del Gesu, Cortona

The University of Georgia Studies Abroad Program's presence year after year has been very valuable to Cortona. It has helped extend the knowledge of our millenary town throughout the world—a knowledge of its environmental and cultural patrimony, and of its spaces and art made to human size. The program fostered the development of relations with other European and even non-European towns and organizations. It has promoted our little town into the appreciated and dynamic tourist attraction that it is today.

Many organizations, institutions, and schools—along with The University of Georgia—choose Cortona to organize courses of study, seminars, and conferences, or to make it the center of their spring and summer activities. For example, we now host the St. Claire School of Oxford, England; the Kantonsschule of Wettingen, Switzerland; and the Koine School, Florence. Others, like the prestigious Scuola Normale Superiore of Pisa and the Feltrinelli Foundation of Milan, have chosen our town as a year-round residence for their cultural and scientific activities.

As for the expansion of international relations, Cortona is today the twin city not only of Athens, but also of the French town of Chateau-Chinon, as well as of the 11th section of Budapest, Hungary. In addition, we also carry on tourism and cultural exchanges with Norway, Yugoslavia, and Denmark.

Perhaps it is most important to remember that Cortona, the city of silence, art, and antique trade, has also become the city of peace. The City Council, on the strength of a century-long heritage of pacifism and internationalism, has declared its territory "a free and denuclearized zone," in both civilian and military purposes, and has initiated a "school for peace," with the determination to promote this strong new culture among its citizens as well as among citizens worldwide.

In the common interest, therefore, we wish for a continuity and further development of The University of Georgia Studies Abroad Program in Cortona, and of the already rich and profitable exchange of Cortonese and American students and teachers.

Giuseppe Favilli
President
Cortona Bureau of Tourism
(translated by Aurelia Ghezzi)

When The University of Georgia began its experiment of resident studies in Cortona twenty years ago, the Bureau of Tourism was very pleased to assist this laudable initiative.

As we now celebrate its twentieth birthday, I would like to express my deep gratitude to program director John Kehoe for

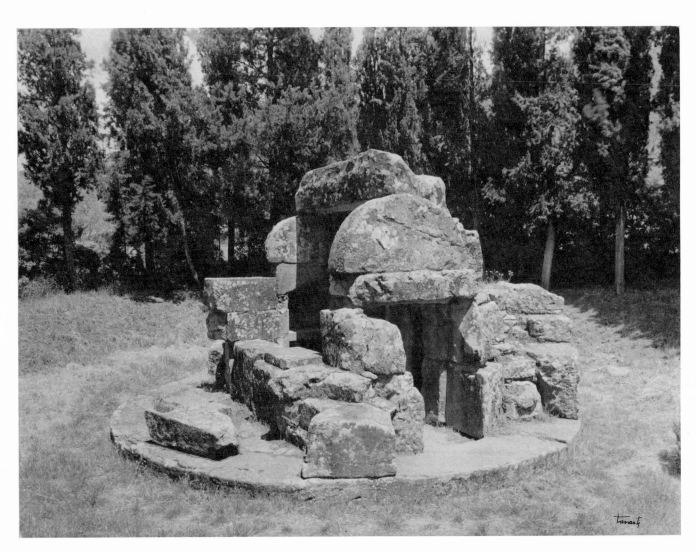

Etruscan Tomb, Cortona

choosing our town as the residence for the Studies Abroad Program. The ideal connection between the young American artists and our great painting masters born in Cortona, as well as the attraction of the Tuscan Renaissance, were certainly instrumental in determining Professor Kehoe's choice.

The goodness and sincerity of our people, the traditional sense of hospitality of the Cortonese (their highest claim of nobility), and the attentive support of the Bureau of Tourism since the very first year of the program have all contributed to the constant improvement of the program, and allow us today to solemnize its success with the presentation of this prestigious exhibition of art and culture.

John D. Kehoe
Director/Founder
The University of Georgia
Studies Abroad Program

Twenty years when compared to the long, glorious history of art in Italy seems only a fraction of a micro-second. Nevertheless, this period has firmly established the relationship between The University of Georgia Studies Abroad Program and the present-day wealth of inspiration that Italy offers American artists.

From a personal vantage point, I can look back over the past and see the incredible amount of talent that the Cortona program has experienced through the involvement of so many individuals. Some were at the beginning of a blossoming career in the visual arts, and Cortona gave them direction. Others were at a midpoint in their professional lives, when the impact of Cortona gave them a new flow of energy. Still others who were at a mature level in their creative work gained fresh insight from this hill town in Tuscany.

When the invitations to participate in this exhibition were extended, the artists responded in a highly gratifying manner. In some ways, it is as if the artists have assembled once again in Cortona's piazza. It is a gathering of men and women who know each other through the shared experience of Cortona. And it is a demonstration of our abiding love for "our town" of Cortona and those simpatici people who have made our lives richer for allowing us the privilege of being part of their world.

I regret that this exhibition cannot accommodate all the very talented Cortona participants. On behalf of the Cortona program and all the students, faculty, and artists-in-residence of these twenty years, I want to thank the exhibiting artists for their generous participation in this exhibition.

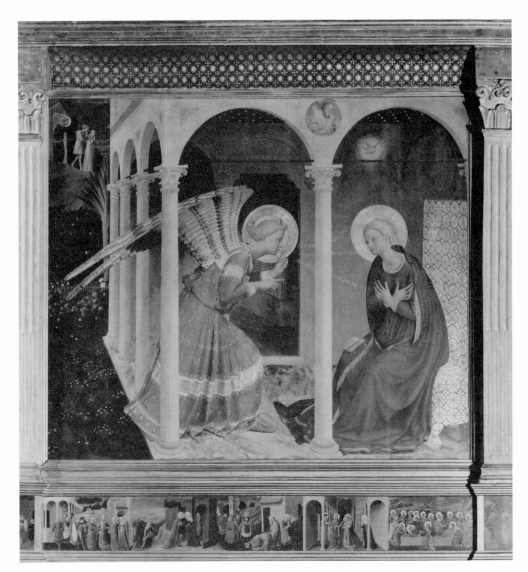

Fra Angelico, *Annunciation*, 1428, Museo Diocesana, Cortona

Jane K. Bledsoe
Director
Georgia Museum of Art

The exceptional influence of programs such as Cortona is evident in the artists' statements that have been collected in this catalogue. Shared experiences and individual epiphanies, prolonged access to great works of art, and a common appreciation for more than two millennia of cultural progress—experiences realized in the Cortona program—have combined to become a seminal event in the participants' development and maturation as artists. The works in this exhibition do not have a single theme, content, or medium, but instead bear testimony to the highest accomplishment in teaching: the development of independent inquiry and expression.

The Georgia Museum of Art is an especially fitting first venue for *City on a Hill: Twenty Years of Artists in Cortona*. It is an exciting privilege to be able to share with the students, faculty, and the community the fruits of twenty years of teaching beyond the campus that is represented by the Studies Abroad Program.

We would like to thank the artists for their participation and for their generous and timely response to the requests from the Studies Abroad office and the museum for catalogue information. This exhibition was conceived by former Georgia Museum of Art Acting Director Carol Winthrop and Cortona Program founder Jack Kehoe. Without their effort and inspiration it would not have come to fruition. Nor could this exhibition have been presented without the support of Governor Joe Frank Harris and University of Georgia President Charles B. Knapp, as well as the regard and generosity of many individual contributors. I would also like to express my appreciation to Governor Harris, President Gianfranco Bartolini, President Knapp, Italo Monacchini, Giuseppe Favilli, and John D. Kehoe for contributing their introductory remarks for this publication. Lastly, I would like to recognize and thank Marion Bowden, Sue Roach, Sylvia Pisani, and Aurelia Ghezzi of the UGA Studies Abroad Program and Patricia Phagan, Peggy Sorrells, and Shan Taylor of the Georgia Museum of Art for the dedication and effort that they provided in assembling the catalogue copy; Dianne Penny for design and production of the catalogue; and Martha Blakeslee for the compilation of the exhibition checklist and for organizing the receiving and shipping of the art works.

Dimensions are given in inches: height, width, and depth. Unless otherwise noted, all works are lent courtesy of the artist.

Catalogue of the Exhibition

Adrienne Anderson

Born Richmond, Virginia, 1949

B.F.A. 1971, M.F.A. 1973, The University of Georgia, Athens

Resides in Atlanta; professor, Department of Commercial Art, American College for the Applied Arts

Artist-Initiated Grant, Georgia Council for the Arts, 1988-1989; Merit Awards, Alabama Watercolor Society, 1980, 1982; Member, American Academy of Arts and Letters, New York City, 1977; Isaac M. Kline Award, *Alabama Art League Annual Exhibition*, 1973

Being associated with The University of Georgia Studies Abroad Program in Cortona, Italy, has given me new experiences, fresh impressions, and historical perspectives and dimensions. The creative and enriching stimuli experienced while living in this ancient and artistically important city has enhanced, energized, and aided in focusing my creative perceptions and awareness.

Travelling Mosaic: Stones of Consciousness (Muse) 1988
Mixed media on canvas
72 x 42

Maria Artemis

Born Greensboro, North Carolina, 1945

B.A. 1969, Agnes Scott College, Decatur, Georgia; M.F.A. 1977, The University of Georgia, Athens

Resides in Atlanta, Georgia; visiting professor, Department of Art, Agnes Scott College, Decatur, Georgia

National Endowment for the Arts Visual Artists Fellowship, 1988; Permanent Site Sculpture Commission, The City of Atlanta and The Arts Festival of Atlanta, 1987; Regional Site Sculpture Award, The Arts Festival of Atlanta, 1985

I spent the summer of 1979 as an artist-in-residence in the UGA Studies Abroad Program in Cortona. Since that time the focus of my work has gradually shifted towards a concern with building indoor and, more recently, outdoor environments—spaces which invite participation and allow multiple readings.

The opportunity to travel and work in Italy provided a rich environment for experimentation with new materials and ideas in my work. My first major indoor installation was completed at the High Museum of Art, Atlanta, in the fall of 1979 and grew directly from my experience in Italy.

Study for "Open Axis" 1987
Graphite on vellum
26 x 32

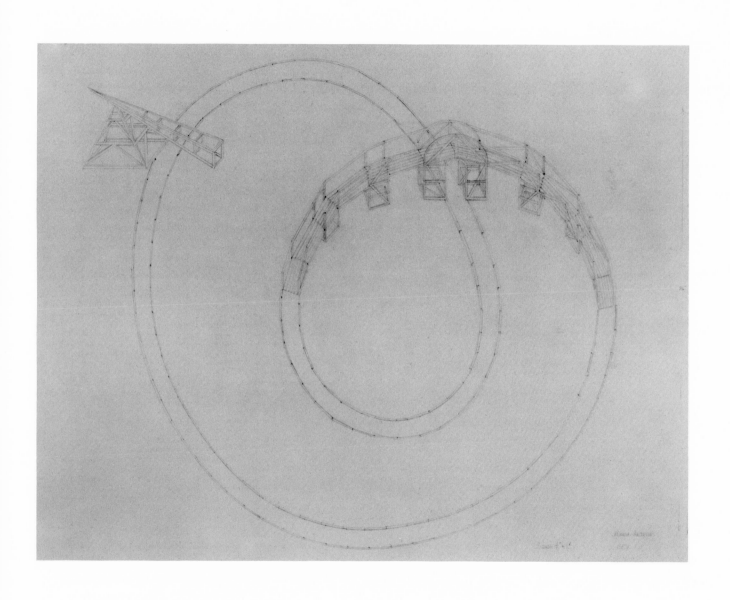

Barry Stone Bailey

Born High Point, North Carolina, 1952

B.S. 1975, M.F.A. 1978, East Carolina University, Greenville, North Carolina

Resides in New Orleans, Louisiana; instructor, Department of Art, Newcomb College, Tulane University

Southern Arts Federation/National Endowment for the Arts Fellowship Award, 1987

The ancient methods of bronze casting and the traditions of stone carving were revealed to me during my stay in the Cortona region. This knowledge came at a critical point as I was finishing graduate school to become a professional sculptor. I also learned the art of frog hunting from my friends at the Marmista in Carmucia. All were techniques I could never forget.

Blade 1988
Cast aluminum
26 x 4½ x 3

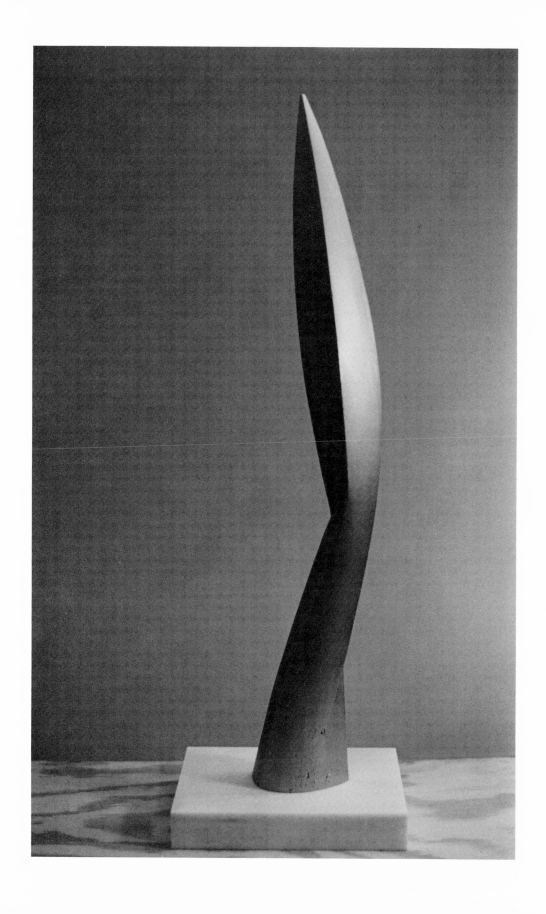

Scott Belville

Born Chicago, Illinois, 1952

M.F.A. 1977, Ohio University

Resides in Spartanburg, South Carolina; assistant professor, Department of Art, Converse College

South Carolina Arts Commission Artists Fellowship, 1988; National Endowment for the Arts Visual Artists Fellowship, 1983; MacDowell Colony Residency, fall 1979; Ford Foundation Grant, 1977-1978

My first trip to Italy was a sensual and spiritual awakening for me. Life's mysteries had never seemed so mysterious. I had the feeling that life was unfolding before my very eyes.

Italy also offered me a direct glimpse into the history of art and with that came a sense of what my own future could be. In Cortona, I learned a new appreciation for how life might be lived on a more human scale. I sensed that the human spirit is alive and well there.

Now, after many trips to Italy, I am still deeply moved by the pure warmth and beauty of Cortona and its people. The mixing of art and life, expressed in so many ways, from the displaying of pastries to the museums and churches, is such an offering. I owe much to that experience and am eternally grateful.

Triumph Over Nature 1987
Oil on paper, mounted on wood
27 x 25 x 2
(detail)

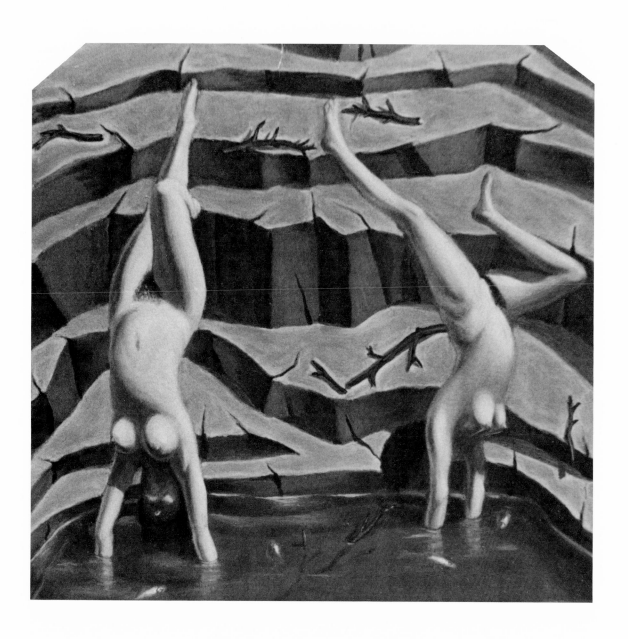

Steve Bickley

Born Lebanon, Virginia, 1953

B.F.A. 1976, East Carolina University, Greenville, North Carolina; M.F.A. 1978, The University of Georgia, Athens

Resides in Blacksburg, Virginia; associate professor, Department of Art and Art History, Virginia Polytechnic Institute and State University

Virginia Museum Fellowship, Virginia Museum of Art, 1985-1986; National Endowment for the Arts Work Stipend, residence at Clayworks Workshop, New York, 1982-1983; Ford Foundation Scholarship, 1977-1978; Region of Tuscany Scholarship, UGA Studies Abroad Program, Cortona, Italy, 1976

The most meaningful life experiences, which reflect in my work, surfaced and were strengthened by my years in Italy. It was in Cortona in 1976 that I felt for the first time I was in a place beyond my concept of time and history. I was smaller than the world and events surrounding me.

My recent sculpture makes references to mystical landmarks and ancient sites in which man perceived himself as a small element of the world. Human symbols, fire, nature forces and religion are evident. Yet I struggle to keep my work abstract, personal, and original.

Atur 1988
Steel
68 x 14 x 12

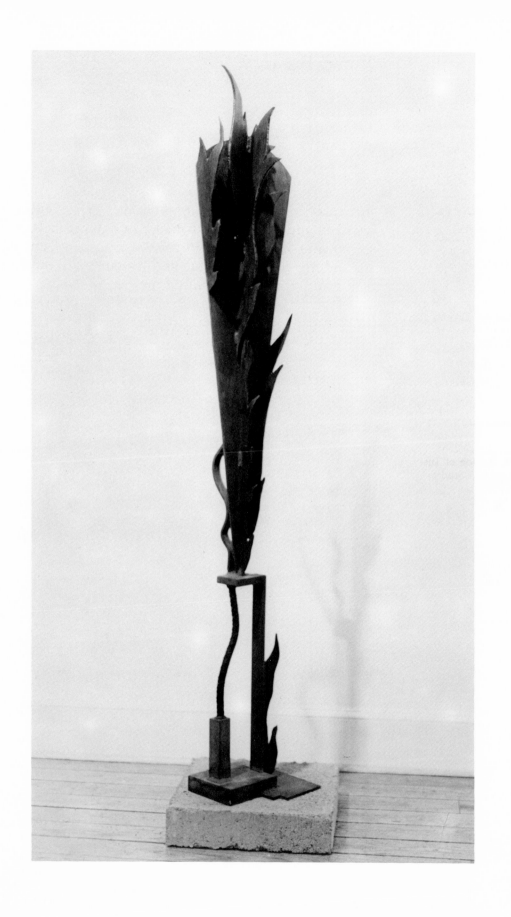

Bruce Bobick

Born Clymer, Pennsylvania, 1941

B.S. 1963, M.Ed. 1967, Indiana University of Pennsylvania, Indiana, Pennsylvania; M.F.A. 1968, University of Notre Dame, South Bend, Indiana

Resides in Carrollton, Georgia; chairman, Department of Art, West Georgia College

Artist-Initiated Grant, Georgia Council for the Arts, 1988; Gold Award, Georgia Watercolor Society, *Seventh National Exhibition, Macon*, 1986; Purchase Award, *14th Annual Watercolor USA*, Springfield Art Museum, Springfield, Missouri, 1975

Cortona had a subtle influence on me. When people found out that I taught painting at a university, they accorded me a certain degree of respect. It was as if I were a direct descendant of the old masters themselves. This attitude is very different from that of people living in America.

Cortona reinforced my belief that to make marks on watercolor paper is an important human activity.

Life Support System for the Test Tube Beans 1980
Watercolor on paper
42 x 27

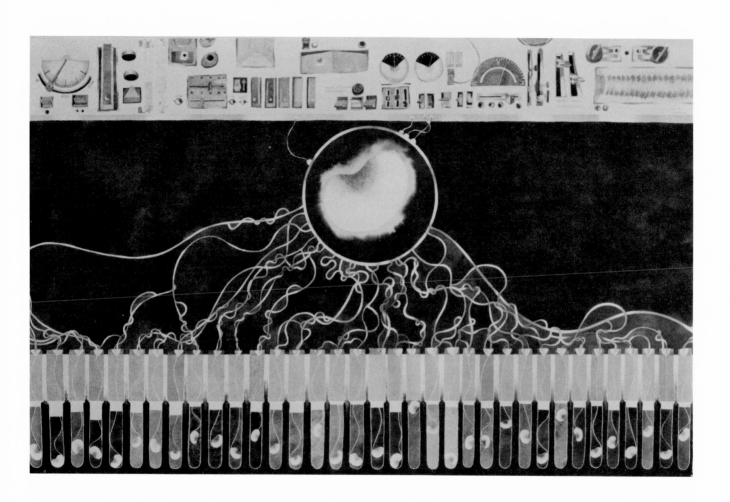

Joseph Bova

Born Houston, Texas, 1941

B.F.A. 1967, University of Houston; M.A. 1969, University of New Mexico, Albuquerque

Resides in Baton Rouge, Louisiana; professor, School of Art, Louisiana State University

Southern Arts Federation/National Endowment for the Arts Fellowship Award, 1985; Louisiana Arts Council Visual Arts Fellowship, 1984; NEA/SECCA Southeastern Artists Fellowship, 1980; Louisiana State University Research Grants, 1974, 1979

The Cortonese name their boys Massimo or Luca, the latter no doubt because it was the home to Luca Signorelli. Another famous artist-resident was Fra Angelico. It was nice to live where such artists worked, but I don't remember that having any effect.

The Italian experience changed the way I thought about image and about the figure in space. It changed my technical approach as well. I came home and put away the colors, threw out the whiteware, and mixed a ton of earthenware and some terra sigillata. Before going to Italy, I had thought terra cotta fit only for flowerpots or roof tiles. I didn't realize the stuff of roof tiles could be a body of art. The Etruscans taught me that.

Bloomingdale Girl 1988
Ceramic
21½ x 18 x 9

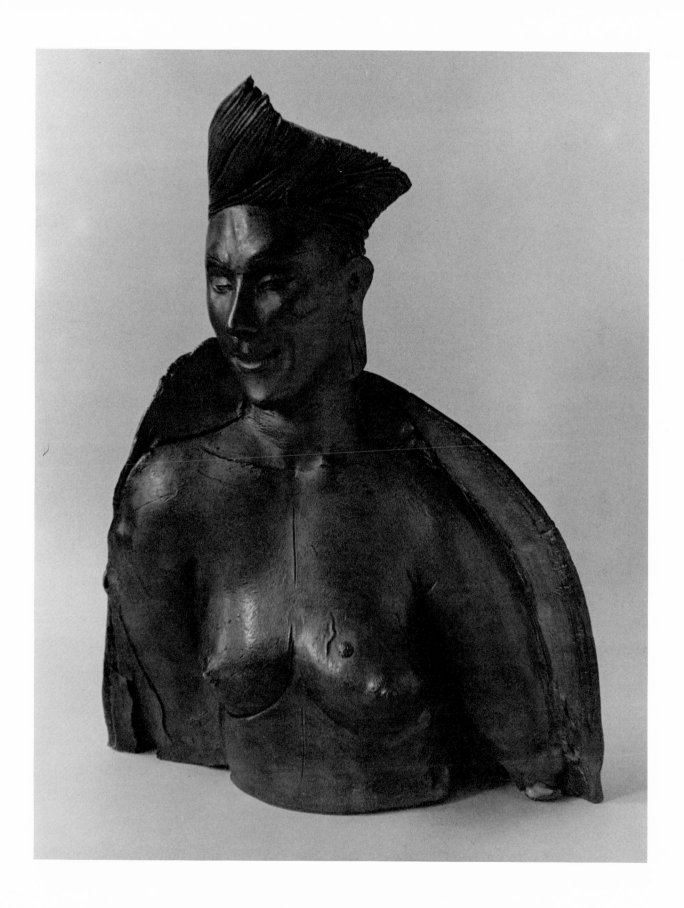

R. G. Brown III

Born Delaware, 1946

B.F.A. 1971, University of Hawaii, Honolulu; M.F.A. 1976, The University of Georgia, Athens; M.L.A. 1984, Harvard University, Cambridge, Massachusetts

Resides in Cambridge, Massachusetts; visiting artist, Department of Art, East Carolina University, Greenville, North Carolina

First Place in Sculpture, *Third Annual Guida di Arezzo Exhibition*, Arezzo, Italy, 1979

I first saw Cortona when I was pursuing my graduate degree in sculpture. It was love at first sight. I have returned ten times and will continue to do so as often as I can. The artist that I was, the artist that I am, and the artist that I will be are all so deeply intertwined with my experiences in Italy that I find it difficult, if not impossible, to separate them from the artistic life I live in the United States. And quite frankly, I don't want to.

Medusa 1980
Italian alabaster
19 x 14 x 26

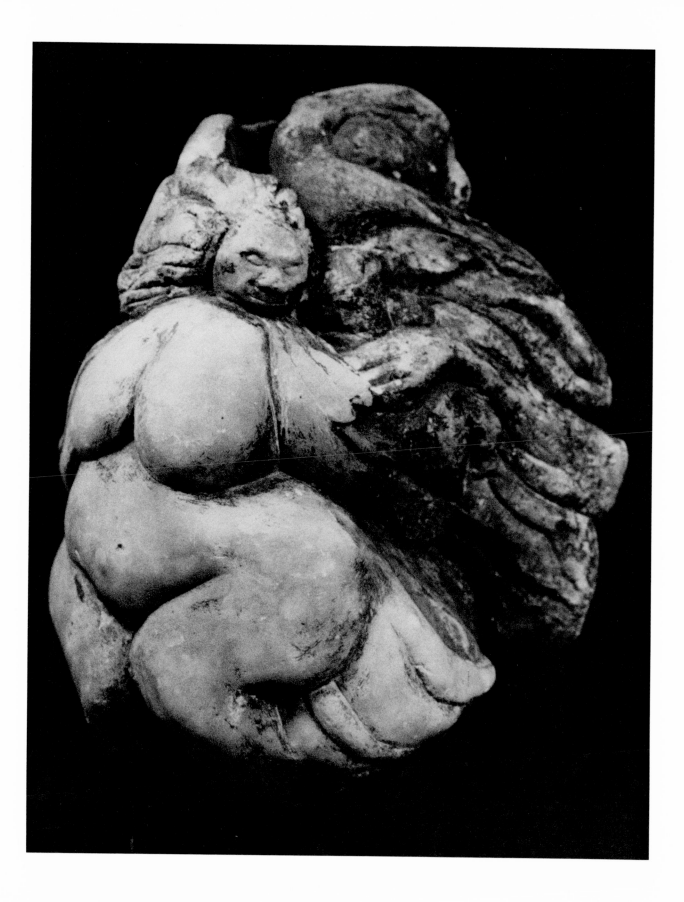

Richard M. Brown

Born Philadelphia, Pennsylvania,
1948

B.F.A. 1973, The University of
Georgia; M.F.A. 1975, Washington
University, St Louis, Missouri;
M.A. 1987, Harvard University,
Cambridge, Massachusetts

Resides in Brookline, Massachu-
setts; instructor, Massachusetts Col-
lege of Art, Boston

Ford Foundation Grant, 1980;
Goldsmith Award, Brooks Memori-
al Art Gallery, Memphis, Tennes-
see, 1974; Ohio State University
Research Grant, 1979

As sculptor/architect it is my intention to investigate the na-
ture of materials, the relationship between the builder and the
process, and ultimately how they affect the outcome of architec-
ture. Nowhere is the act of building and its relation to the de-
velopment of culture more clearly stated than in architecture.

*Architectural Design for Library/Art Gallery/Meeting Hall for
Hambidge Center for Creative Arts and Sciences* 1988
Wood
12 x 24 x 8

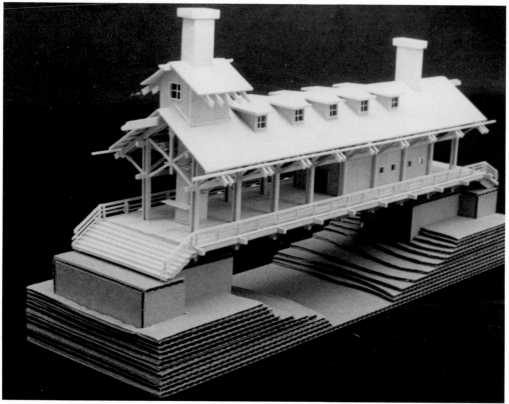

Vee Brown

Born Atlanta, Georgia, 1947

B.V.A. 1969, M.V.A. 1973, Georgia State University, Atlanta

Resides in LaGrange, Georgia; professor, Department of Art, LaGrange College

After the many years that have passed since my visit to Cortona in 1972, all I have left are some sketchbooks, photographs, and memories. The memories seem most fertile to explore, like dreams or visions, and it is with serendipitous postcards that I like to spin visual tales of something both concrete and cosmic, especially as I think about Cortona being almost on the other side of a planet in an infinite universe.

Vision of an Etruscan Tomb 1988
Acrylic and collage on wood
11 x 12

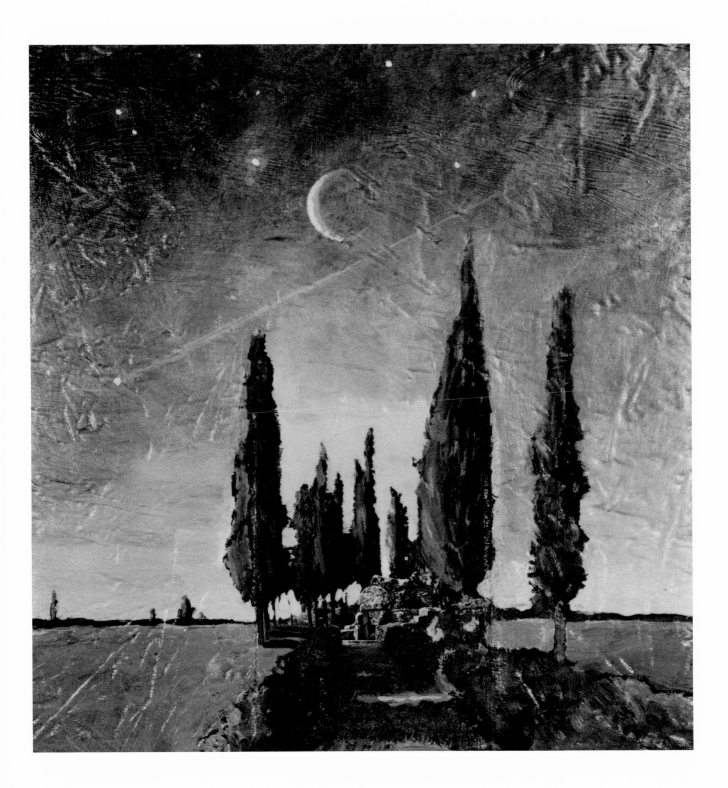

Dianne C. Cable

Born Haywood County, North Carolina, 1949

B.A. 1973, University of North Carolina at Asheville; M.A. 1983, The University of Georgia, Athens

Resides in Richmond, Virginia; graduate student and teaching assistant, Department of Art, Virginia Commonwealth University

The University of Georgia Studies Abroad Program in Cortona has provided me with an intense experience. This experience has been working with professional artists, university faculty, and students from across the United States in a small, beautiful Italian city located high on a hill above the Val di Chiana in Tuscany. Such an experience has provided invaluable artistic growth. The "Cortona Experience" continues to be a major factor in my work, not only visually but spiritually as well.

Wal, Blow Me Down 1987
Oil on canvas
72 x 60

Alan Campbell

Born Athens, Georgia 1950

B.F.A. 1973, M.F.A. 1976, The University of Georgia, Athens

Resides in Athens, Georgia; artist

Official Designated Artist, United States Antarctic Program, McMurdo Station, Antarctica, 1987-1988; Georgia Governor's Artist of Excellence, 1985; Georgia Council for the Arts Artist-Initiated Grant, 1983-1984; Ossabaw Island Project Member, Ossabaw Island, Georgia, 1982, 1979

Cortona is a city of dreams, and a haven for a dreamer. I dreamed of Cortona before my first trip as a student in 1971, the second year of the Georgia program. I remember how it appeared as a vision in the distance through rows of umbrella pines as I gazed through the front window of our bus. And after returning as a student in 1973, as a teacher in 1977, and as a visitor just to paint in 1985, I dream of it still, often picturing the view from the Val di Chiana at night when the town looks so much like a shower of stars cast across the mountaintop. That my work still shows the influence of Cortona is obvious: oblique views into landscapes with no horizons, an abiding interest in architecture and form, and a fascination with color and light that has carried me as far as Antarctica. All of these elements can be traced to long, hot days under Tuscan light and silent nights among the stars in Cortona. I will always find a way back to this most special place, both in my work and in person.

Santa Maria Nuova 1985
Watercolor on paper
14 x 22
Collection of Mr. and Mrs. Charles O. Smith Jr.

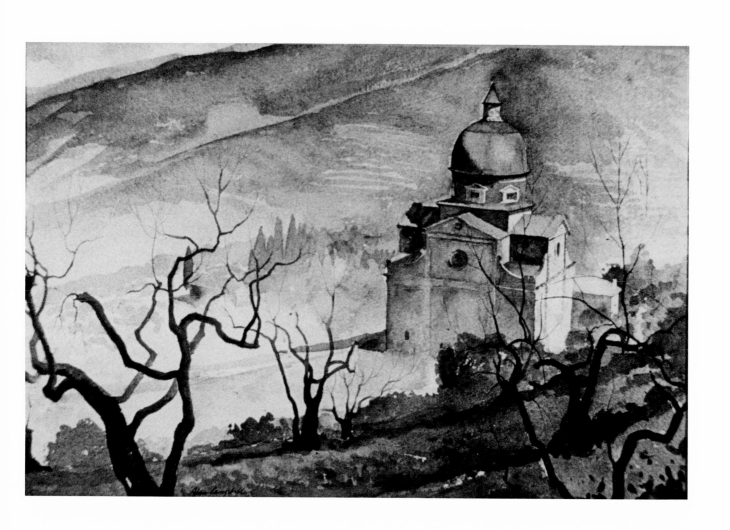

Dean Carter

Born Henderson, North Carolina, 1922

A.B. 1947, American University, Washington, D.C.; M.F.A. 1948, Indiana University, Bloomington

Resides in Blacksburg, Virginia; professor, Department of Art and Art History, Virginia Polytechnic Institute and State University

VPI and SU Educational Foundation Supplemental Grant for European Travel, 1983; Sidney's Sculpture Award, *Festival in the Park*, Roanoke, Virginia, 1975; First Prize, *Painters and Sculptors Society of New Jersey Exhibition*, Jersey City Museum, 1956

Statement of Purpose:

To express my experiences of living through the medium of sculpture.

To express my feelings of happiness and sorrow through the sincere forms in sculpture.

To create sculpture worthy of the great heritage that all sculptors possess today.

To anticipate new forms through new thoughts, new ideas, and new uses of sculpture.

To make a sculpture an exciting experience for all who see and feel it.

To create interesting tactile and visual forms in sculpture.

Figure 1986
Alabaster
6 x 14 x 6

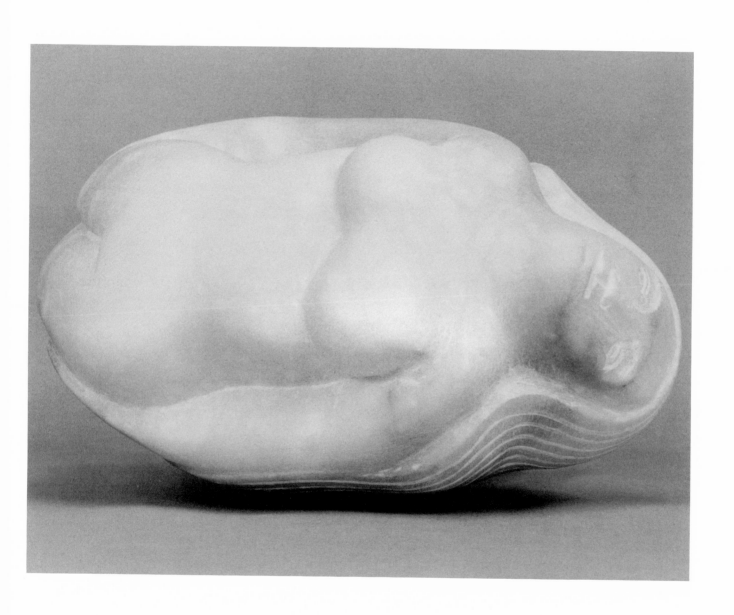

Georgia Deal

Born New York City, 1953

B.F.A. 1975, Virginia Polytechnic Institute and State University, Blacksburg; M.F.A. 1977, The University of Georgia, Athens

Resides in Washington, D.C.; chairman, Department of Printmaking and Papermaking, Corcoran School of Art

William H. Walker Purchase Award, Philadelphia Museum of Art, *Philadelphia Print Club Annual Exhibition*, 1981; Installation Grant, Washington Project for the Arts, Washington, D.C., 1983; New York State Council for the Arts Artists Fellowship, 1984

Five years after my summer in Cortona, I can still say it has a strong effect on my work. Such a rich cultural experience, combined with the time and quiet provided in our studios, allowed so much to happen, to germinate, that today still I find images and ideas resurfacing.

She Walk the Street, She Do the Do 1986
Etching on paper
18 x 20

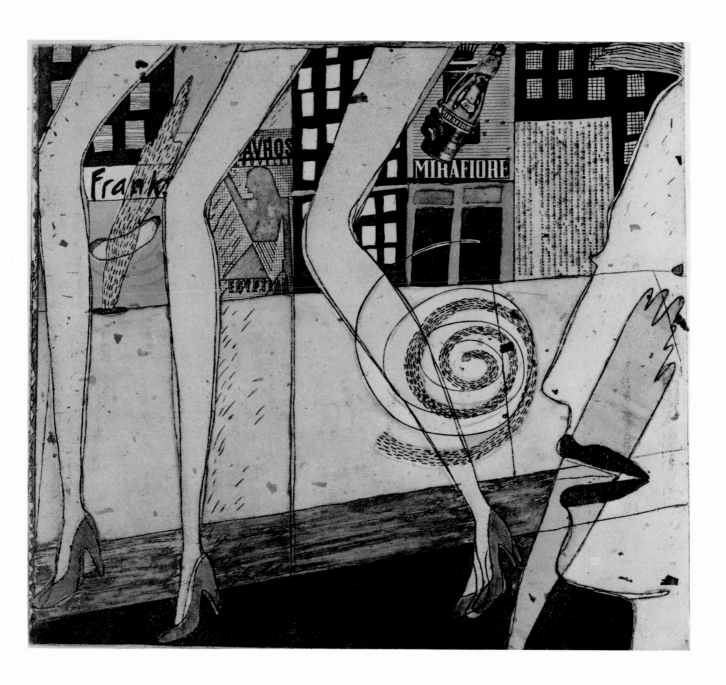

Irene Dodd

Born Athens, Georgia, 1941

A.B. 1964, Duke University, Durham, North Carolina; M.F.A. 1967, The University of Georgia, Athens

Resides in Valdosta, Georgia; professor, Department of Art, Valdosta State College

NASA guest, launching of Apollo XVII and Skylab IV, 1972, 1973

I have a love relationship with Cortona, Italy—the people, the narrow ascending and descending streets, the pasta, the medieval buildings. This love for Italy began in 1954 when I cried when we left Italy as a family after two months of traveling. The country, the art, and the people had become a part of me. In 1978 when I returned to Italy for a third visit, as an artist-in-residence in the UGA Cortona Studies Abroad Program, a part of me felt that I was coming home. Each afternoon from my apartment, I thrilled to the orange sunlight bathing the repeating, interwoven valleys and lakes or to a column of rain moving toward the hilltop towns. As I sketched and watercolored in the olive groves, it wasn't just the subject matter or the scenery that inspired me, but the entire experience of Italy and the Italians. This experience is alive in me even now as I teach art history and painting and complete my own professional works. Over the past nineteen summers, I have encouraged a number of students to apply for the UGA Studies Abroad Program. All who returned from the summer in Cortona were enthusiastic and able to see the world around them and the people more sensitively. They, too, have been indelibly marked by the Cortona experience.

Rain 1984
Watercolor on paper
29 x 38

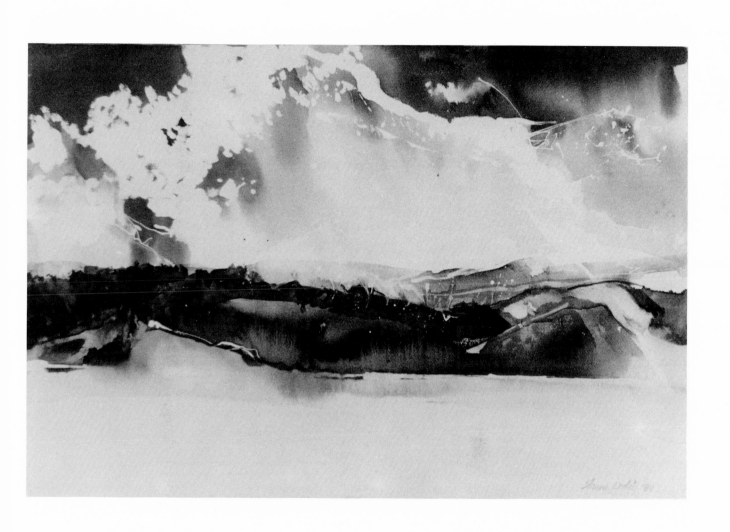

Lamar Dodd

Born Fairburn, Georgia, 1909

Georgia Institute of Technology, School of Architecture, Atlanta, 1926-1927; Art Students League, New York City, 1928-1933

Resides in Athens, Georgia; professor emeritus, Department of Art, The University of Georgia

Georgia Governor's Award in the Arts, Georgia Council for the Arts, 1974; Official Artist for NASA, 1963-present; elected Fellow, Royal Society of Arts, London, 1970; Edwin Palmer Memorial Prize, *National Academy of Design Annual Exhibition*, 1953; Norman Wait Harris Award, *Art Institute of Chicago Annual Exhibition of American Painting and Sculpture*, 1936; Purchase Prize in Watercolor, *Southern States Art League Annual Exhibition*, 1931

I do not usually consider the title of the painting I create to be of utmost importance, but in this case I do. *Decision—God and Man* relates to a series of paintings I did during the late 1970s and early 1980s. These drawings and paintings were an outgrowth of an ongoing personal experience directly associated with birth and rebirth.

I believe that God creates man and man can only recreate.

Faced with a critical decision as to when or not a lifesaving operation is necessary to preserve life, questions are raised that reach far beyond the stages of reality. I was faced with such a decision.

If in this expression one perceives forms relating to the *Pieta*, I am pleased; however, if one senses doctors contemplating action before performing bypass heart surgery, I am equally gratified.

The Decision: God and Man 1982-1983
Mixed media with silver leaf on masonite
32 x 40

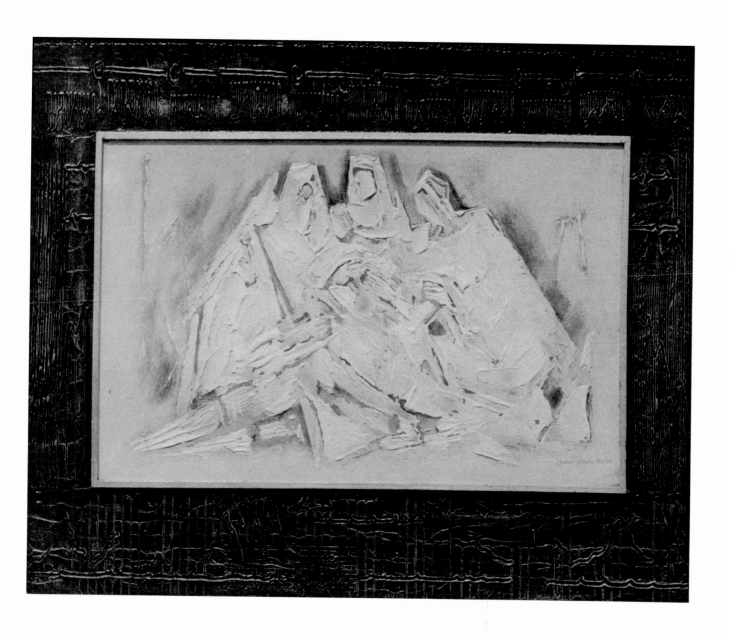

Horace L. Farlowe

Born Robbins, North Carolina, 1933

B.S. 1963, Atlantic Christian College, Wilson, North Carolina; M.A. 1964, East Carolina University, Greenville, North Carolina

Resides in Athens, Georgia; associate professor, Department of Art, The University of Georgia

Sculpture Commission, Cumberland County Public Library, Fayetteville, North Carolina, 1986; two Purchase Awards, *Third Annual North Carolina Sculpture Exhibition*, Northern Telecom, Research Triangle Park, North Carolina, 1984

The Cortona program has been a rich experience for me. In my visits to Cortona I have always been successful in producing sculptures in marble. Working in the beautiful Italian sunlight alongside students and sharing the joy of carving Italian marble is very rewarding. It's a Cortona experience.

Tennessee Cut 1987
Tennessee marble
28 x 23½ x 20

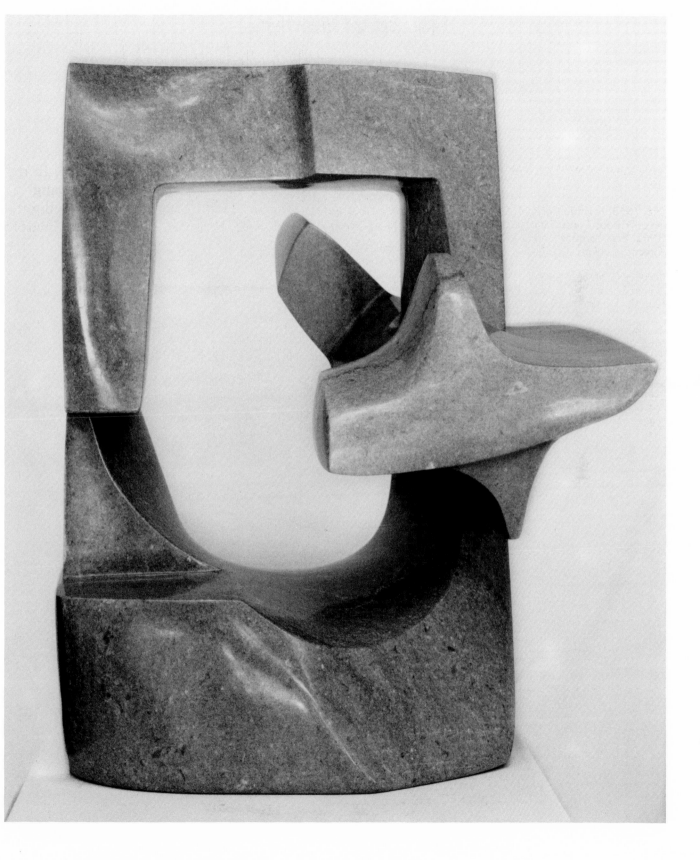

Christine Federighi

Born San Mateo, California, 1949

B.F.A. 1972, Cleveland Institute of
Art, Cleveland, Ohio; M.F.A. 1974,
New York State College of Ce-
ramics at Alfred University, Alfred,
New York

Resides in Miami, Florida; profes-
sor, Department of Art and Art
History, University of Miami,
Coral Gables

NEA Individual Artist Fellowship,
1988-1989; Florida Fine Arts
Council Individual Artist Fellow-
ships, 1979, 1983; NEA/SECCA
Southeastern Artists Fellowship,
1981; Purchase Award *Florida
Craftsman Show*, Florida Interna-
tional University, Miami, 1979

Time spent in Italy gave me reflective moments...a time to turn
the regular world upside down...breathing space...and a new
way of seeing the past and the present.

Winter Wood 1988
Terra cotta with oil patina
68 x 12 x 12½

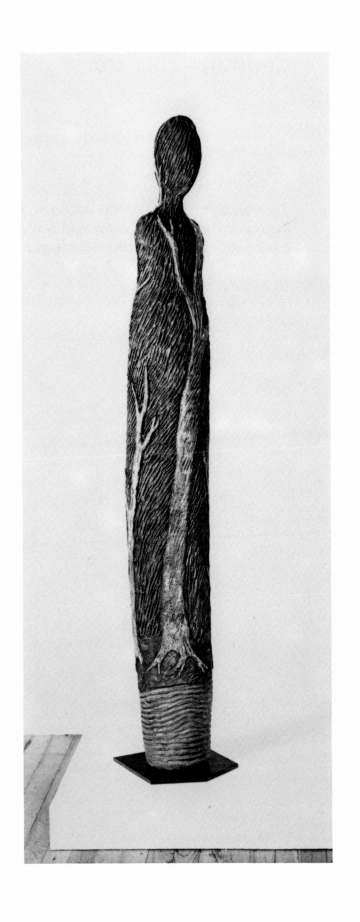

Eric Estes Fitzpatrick

Born Roanoke, Virginia, 1953

B.F.A. 1975, Virginia Polytechnic
Institute and State University,
Blacksburg

Resides in Roanoke, Virginia; artist

First Place, mixed media, *Cuyahoga
International Invitational Exhibi-
tion*, Cuyahoga Falls, Ohio, 1986;
First Place, sculpture, *Religion in
the Arts Invitational*, Roanoke, Vir-
ginia, 1980; First Place, watercolor,
Bath County Invitational, Warm
Springs, Virginia, 1976

There will always be a place in my heart for Cortona and the
Cortonese. Cortona is my second home, in a sense, since I
spent five summers of study there. It represents so many things
to me, but above all, the acceleration of the learning process.
The work done in Cortona is *always* my best and usually a
quantum leap from my normal rate of artistic progression in
the United States. I feel very blessed that Cortona has been a
part of my life.

Orvieto Courtyard 1980
Watercolor on paper
14 x 10

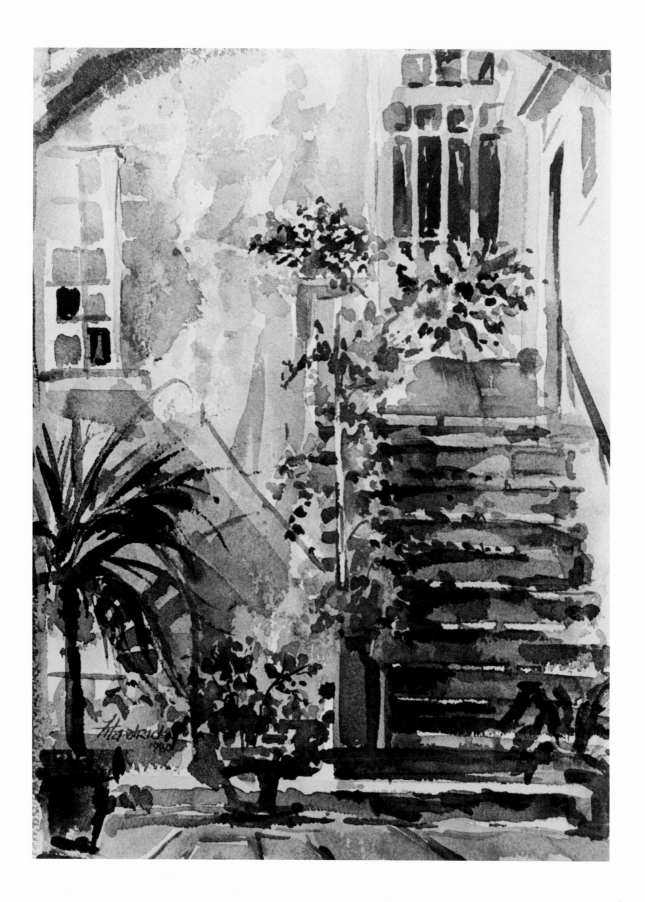

Cheryl Goldsleger

Born Philadelphia, Pennsylvania, 1951

B.F.A. 1973, Philadlephia College of Art, Philadelphia, Pennsylvania; M.F.A. 1975, Washington University, St. Louis, Missouri

Resides in Athens, Georgia; head and assistant professor, Department of Art, Piedmont College, Demorest, Georgia

NEA/SECCA Southeastern Artists Fellowship, 1986; National Endowment for the Arts Visual Artists Fellowship, 1982; Pennsylvania Council on the Arts Creative Artists Fellowship, 1981

Italy and the Italian culture have had a great influence on my work. The Cortona program provided me the wonderful opportunity of living and working in an ancient Italian town for an extended period of time. The most influential aspect of Italian culture on my painting has been the architecture. Remnants of places once used is something I try to reconstruct in my paintings and drawings. The feelings I have had walking through the ancient ruins have had a profound effect on me. These experiences in conjunction with the advantage of extensive, firsthand opportunity to study all of the great Italian works of art from throughout art history have been invaluable.

Restricted Passage 1986
Oil, dry pigment, and wax on linen
24 x 30
Courtesy Bertha Urdang Gallery, New York City

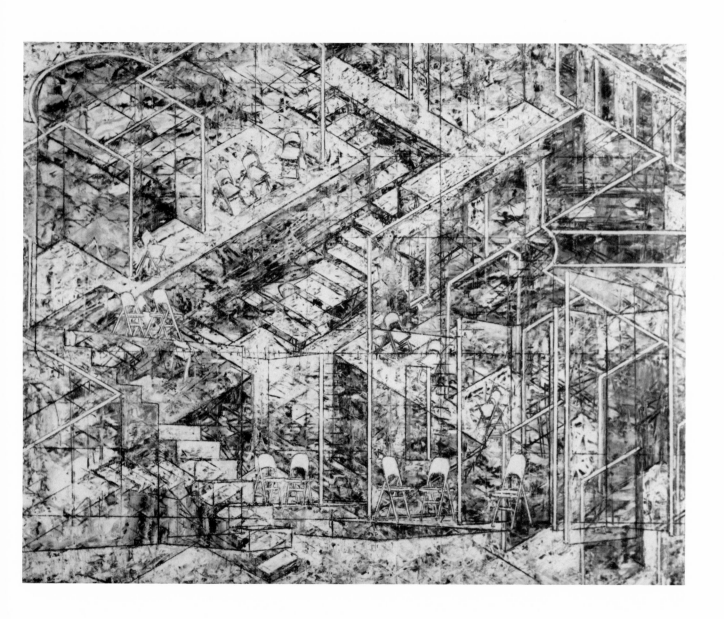

John Goodheart

Born Baltimore, Maryland, 1940

M.F.A. 1963, East Carolina University, Greenville, North Carolina

Resides in Bloomington, Indiana; director, School of Fine Arts, Indiana University

Purchase Award, *Mid-States Craft Exhibition*, Evansville Museum of Art, Evansville, Indiana, 1972; Honorable Mention, *Metal, Clay, Fiber: Annual Piedmont Crafts Exhibition*, Mint Museum of Art, Charlotte, North Carolina, 1964

The natural beauty of the Italian countryside, combined with an extraordinary artistic heritage makes Italy a visually and intellectually enriched environment for any artist.

The opportunity to live and work in Cortona was a great experience. The architecture, the sense of history, and the enlightened attitude of the Cortonese made my stay very special.

How the Brain Works 1988
Ceramic
11 (diameter)

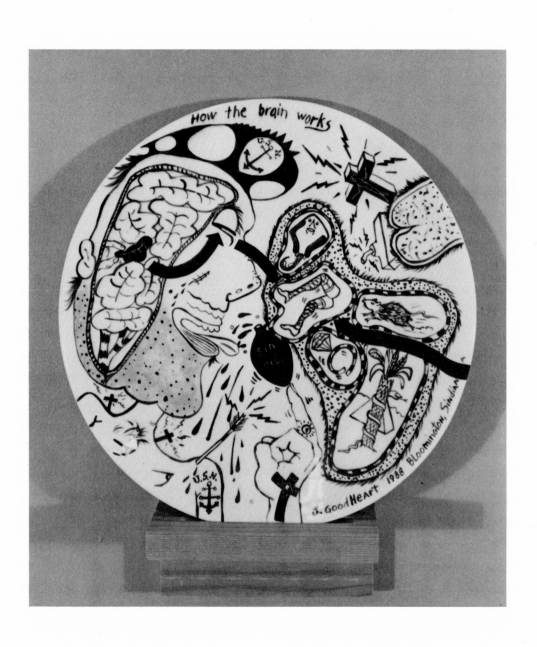

Jack Gron

Born Steubenville, Ohio, 1951

B.F.A. 1973, Columbus College of Art and Design, Columbus, Ohio; M.F.A. 1976, Washington University, St. Louis, Missouri

Resides in Lexington, Kentucky; associate professor, Department of Art, College of Fine Arts, University of Kentucky

Commission for public sculpture, Elmwood Park, Illinois, 1980; Commission for public sculpture, Olympia Fields, Illinois First Suburban Bank, 1977

The Cortona experience is one which will live with me forever. The memories and impressions almost daily creep into my life and into my work. The influences upon my expression are only now beginning to surface in my sculpture. I feel honored and privileged to have been part of this remarkable program and I eagerly look forward to the day when I can return to that beautiful city.

Medieval Modern Chastity 1987
Marble and steel
27 x 24 x 12

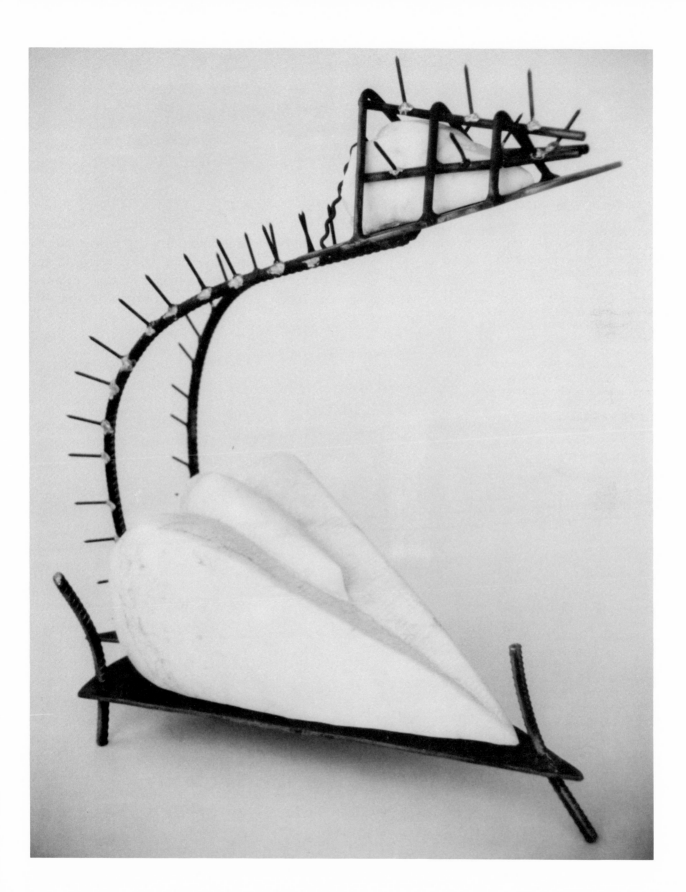

Mary Sayer Hammond

Born Bellingham, Washington, 1946

B.F.A. 1967, M.F.A. 1977, The University of Georgia, Athens; Ph.D. 1986, The Ohio State University, Columbus

Resides in Fairfax, Virginia; associate professor, Department of Art, George Mason University

Johnson Mathey Corporation Materials Grant, 1987; Samuel H. Kress Foundation Grant, 1984; National Endowment for the Arts Visual Artists Fellowships, 1982-1984; Polaroid Foundation Artist Support Grants, 1983-1986; Fulbright-Hayes Research Grant, Italy, 1973-1974

In Italy, time hovers, is mist-like. As its entire history stretches out before the eye, Italy becomes timeless with its surreal sense of place. What has been commingles with what is now and suggests the future. Change is so gradual that it often becomes imperceptible. A photograph is supposed to capture a fleeting moment in time and freeze it for eternity. The eternity of Italy already exists, however, in the reality of the place. For me, photographing there is like seeing in slow motion. I delight in discovering the subtle nuances of its ephemeral evolution.

Burano Laundry 1984
Type C color print
4¾ x 14

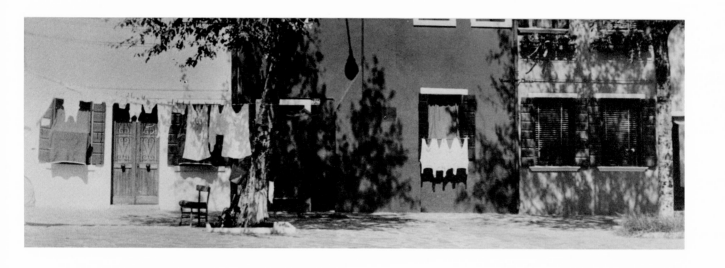

Tom Hammond

Born Lumberton, North Carolina, 1939

B.S. 1962, M.A. 1964, East Carolina University, Greenville, North Carolina; The Chicago Academy of Fine Arts, Diploma in Art, 1959

Resides in Athens, Georgia; associate professor, Department of Art, The University of Georgia

Purchase Award, Museum of Arts and Sciences, Macon, Georgia, 1986; Purchase Award, The Penland School of Arts and Crafts, Penland, North Carolina, 1986; Purchase Awards, Georgia Council for the Arts and Humanities, 1971, 1975, 1983; Purchase Award, West Georgia College, Carrollton, 1980; Purchase Award, University of South Carolina at Spartanburg, 1980

My work today seems vastly different from drawings done in 1973 at Cortona's fortress wall. Yet comparisons reveal connections, a continuous thread and a constant flow. There is no gap between then and now.

Kudzu Topiary 1988
Colored inks on Japan paper

Barbara Lynn Hanger

Born Waynesboro, Virginia, 1953

B.F.A. 1976, The University of
Georgia, Athens; M.F.A. 1979,
Ohio University, Athens

Resides in Louisville, Kentucky;
associate professor, Allen R. Hite
Art Institute, University of Louis-
ville

Kentucky Foundation for Women
Research Grant, 1987; Kentucky
Arts Council Grant for Artists'
Support, 1984; Ohio Arts Council
Individual Artists Fellowship, 1981

Ever since my first trip to Cortona in 1975, memories of Italy have influenced my work daily. These memories plus things yet to be discovered have pulled me back to Cortona six additional times and will undoubtedly continue to exert their spell over me in the future. Some of these influences are the landscape of the Val di Chiana, Tuscan light, Venetian architecture, Etruscan objects, Giotto, della Francesca, Fra Angelico, Botticelli, and Morandi.

Around the Well 1986
Colored pencil on gessoed masonite
30 x 44

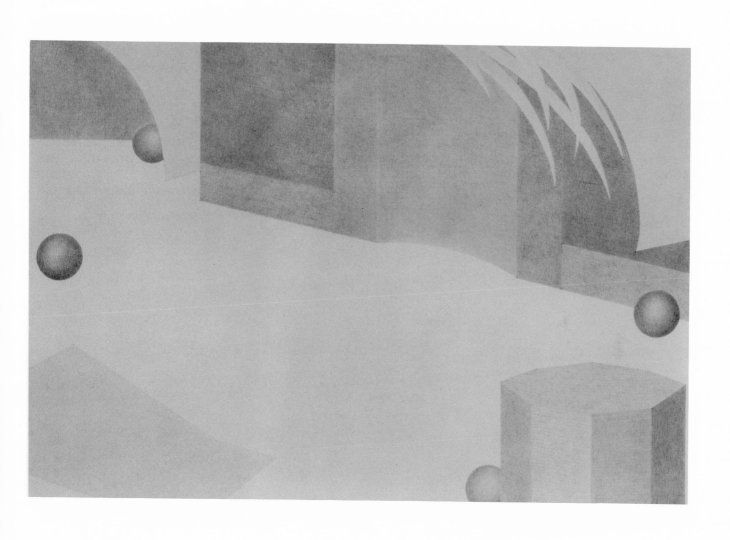

Tony Hepburn

Born London, England, 1942

N.D.D. 1963, Camberwell College of Art, London; A.T.P. 1965, London University

Resides in Alfred, New York; professor, School of Art and Design, New York College of Ceramics at Alfred University

National Endowment for the Arts Visual Artists Fellowship, 1986; New York State Council on the Arts Artists Fellowship, 1986

The studio, sixteenth-century monastery. High walls, vaulted ceilings, adorned with frescoes depicting the stations of the cross. Cross-cultural connections to Barrett Newman sections. Damp smells, humidity, the travel of sound. The courtyard captured by changing light. Decay, echoing with singular thoughts and chanting. Gessoed canvas, dusty charcoal, and red conte crayon, as though chipped from the crumbling terracotta roofs. Spiritual and transient, a speck in 400 years of changing use. Creaking but substantial. From peering eyes in the murk of small light bulbs dangling from sinewy bare cords, to blinding sunlight...the adjustment of different worlds. Attacking the canvas, wondering how the images came about, how much control, how little, letting go, accepting. Burning bones in pizza ovens, staining cloth, rubbing, pacing, and smelling. The reek of religion. What a powerful force it must be.

This work may begin and end in this space.

Matches 1988
Clay, wood, metal, and leather
24 x 18 x 16

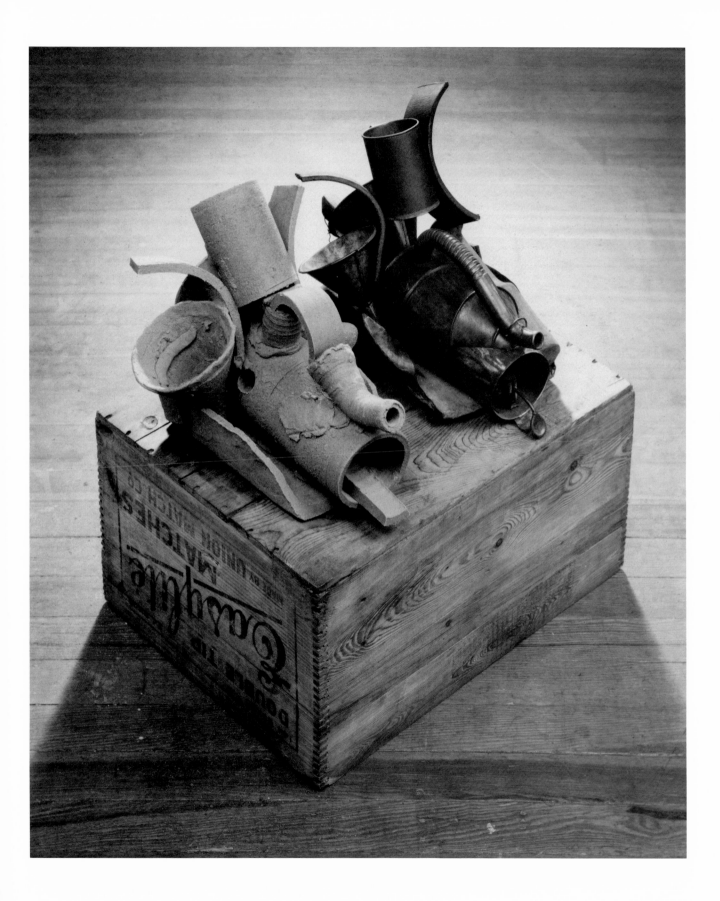

Hal Howe

Born Chicago, Illinois, 1936

B.F.A. 1967, Atlanta College of Art, Atlanta, Georgia; M.F.A. 1970, The University of Georgia, Athens

Resides in Athens, Georgia; professor, Department of Art, The University of Georgia

MacDowell Colony Fellowship, 1982; NEA/SECCA Southeastern Artists Fellowship, 1980; Outstanding Painter Award, 1967, Atlanta College of Art

Always, in my mind's eye, I see the geometry of Cortona's passageways, and their complex simplicity.

Duo 1987
Acrylic on paper
23 x 30

Marcia Isaacson

Born, Atlanta, Georgia, 1945

B.F.A. 1966, M.F.A. 1970, The University of Georgia, Athens

Resides in Gainesville, Florida; associate professor, Department of Art, University of Florida

NEA/SECCA Southeastern Artists Fellowship, 1978; MacDowell Colony Residency, 1977; The University of Georgia Studies Abroad Program, Cortona, Italy, Artist-in-Residence, 1978; Florida Fine Arts Council Individual Artist Fellowship, 1978; Teacher of the Year Award, University of Florida, College of Fine Arts, 1977-1978

I still remember, after ten years, my studio in Cortona—high ceilings, always cool, overlooking a courtyard full of sculptures in progress. I found myself looking at surfaces there: floors, walls of tile, brick, stone, and stucco; surfaces aged by weather and time and built up of layers of materials. In these surfaces forms seemed to emerge and submerge, revealing and concealing mysterious shapes. Every view was art. Everyone around me was making art. To be again in such a place!

Melanie Across a Chair 1987
Graphite on paper
30 x 41

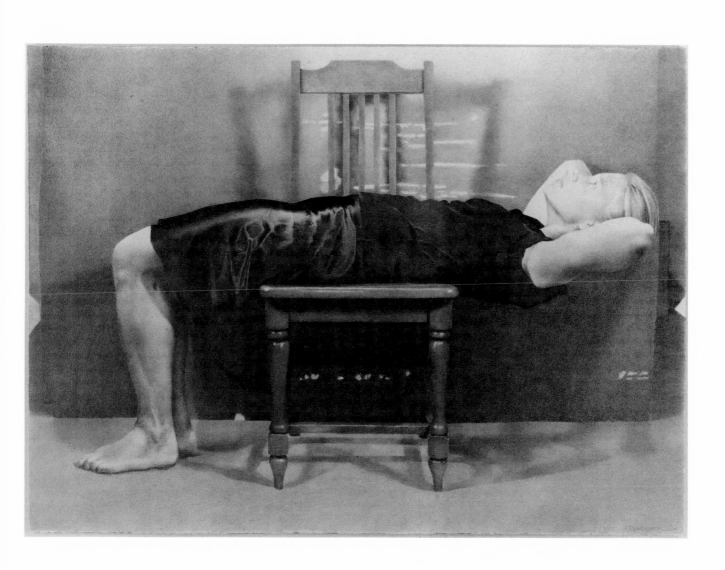

Roger Jamison

Born Quinter, Kansas, 1947

B.F.A. 1970, Bethany College, Lindsborg, Kansas; M.F.A. 1974, Indiana University, Bloomington

Resides in Juliette, Georgia; chairman, Department of Art, Mercer University, Macon

Kansas Designer Craftsman's Award, clay, 1973; cor-ten steel sculpture, Macon Chamber of Commerce Building, Macon, Georgia, 1976

For an American, even one living in an "old" house in the historic district of an East Coast city, the thing I keep coming 'round to as I remember Cortona is the way history lives in the lives of everyone who goes there. We shared sights, forms, spaces, textures of landscapes, art, and architecture with Umbrians, Etruscans, the Medici, and others who have occupied this site. It is something we don't have just yet in our young country but it flavors every experience in Cortona. In particular it spices the activity of art-making with inspiration of past achievements and challenges us to live up to them.

Trout Platter 1988
Ceramic
12 x 18 x 3

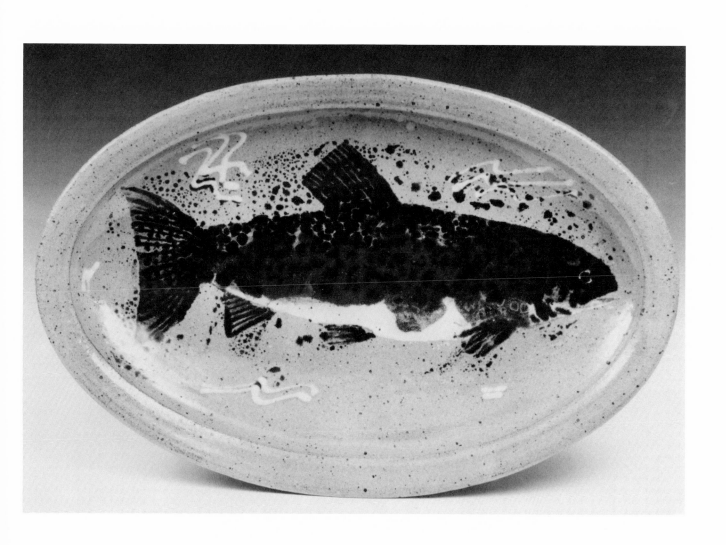

Wendy Jeffers

Born Providence, Rhode Island, 1948

B.F.A. 1971, University of Massachusetts, Amherst; M.F.A. 1974, Pratt Institute, Brooklyn, New York

Resides in New York City; freelance curator

MacDowell Colony Residency, 1977; Max Beckman Fellowship, Brooklyn Museum, 1971-1972

Cortona reacquainted me with qualities which are often missing from my own hectic urban existence. Such commonplace activities as sitting in an outdoor cafe, strolling through the winding streets, or eating a meal become an occasion to celebrate life. How difficult it is now to recapture that special pleasure of a peaceful inner life in the midst of the complexities of "sophisticated American living" and look to my heart for the answers to the questions of significance. I remember with great fondness the humor, hospitality, and hearty good times I have had with the Cortonese, but also what they showed me about my spirit.

The Road to Cortona 1985
Graphite on paper
13¾ x 19¾

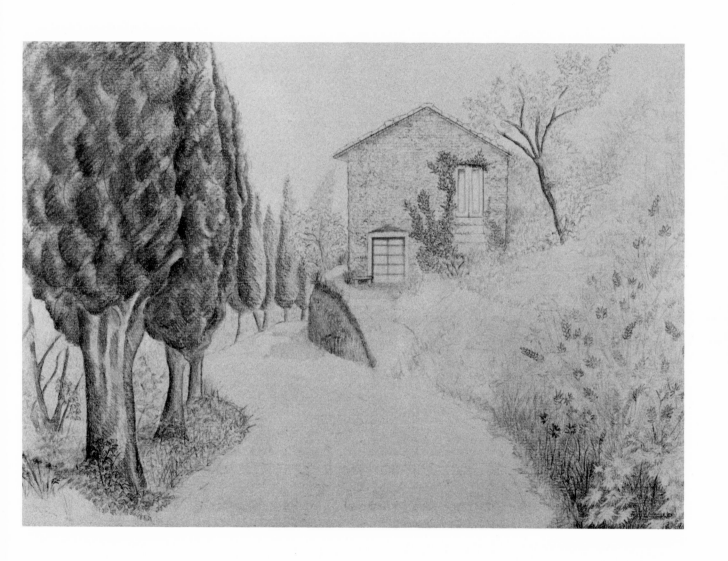

Richard Johnson

Born Vicksburg, Mississippi, 1946

B.F.A. 1969, Louisiana State University, Baton Rouge; M.Ed. 1970, Ed.S. 1971, M.F.A. 1976, The University of Georgia, Athens

Resides in Watkinsville, Georgia; associate professor, Department of Art, The University of Georgia

Cortona has certainly had a profound influence on my work, my person. Five summers wandering those hillsides have excited my artistic intentions (and hopefully the results) but paradoxically claimed my soul. This collaborative book used Cortona through twenty centuries as a backdrop for poetry and photography.

Una Giornata 1986
Handmade book
8½ x 11½

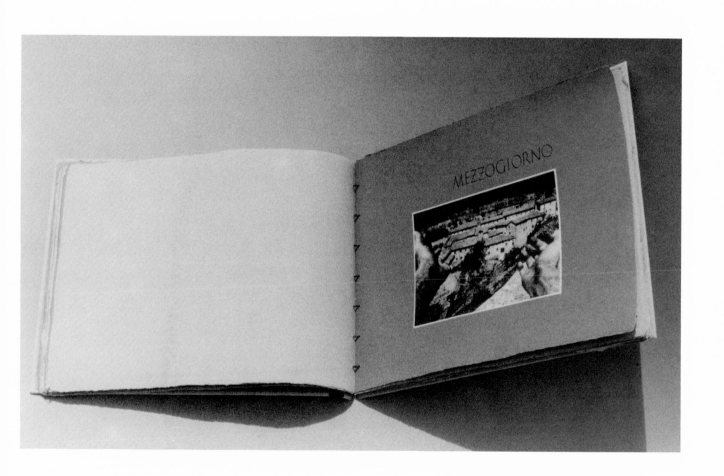

Judy V. Jones

Born Winston-Salem, North Carolina, 1949

B.F.A. 1972, M.F.A. 1976, The University of Georgia, Athens

Resides in Spartanburg, South Carolina; chairperson and associate professor, Department of Art, Converse College

South Carolina Arts Commission Artists Fellowships, 1981, 1987; South Carolina Arts Commission Individual Artists Grant, 1984

It is difficult to speak of Cortona without sounding sentimental. After spending much time in this city, I've realized that what I feel for Cortona and its people is not just an emotion that only overcomes me in the dead of winter or in my moments of boredom. Almost daily I think of my time there. Hopefully my life and work will always be interwoven with Italy and its gracious people.

Puzzle 1988
Oil on canvas
26 x 26

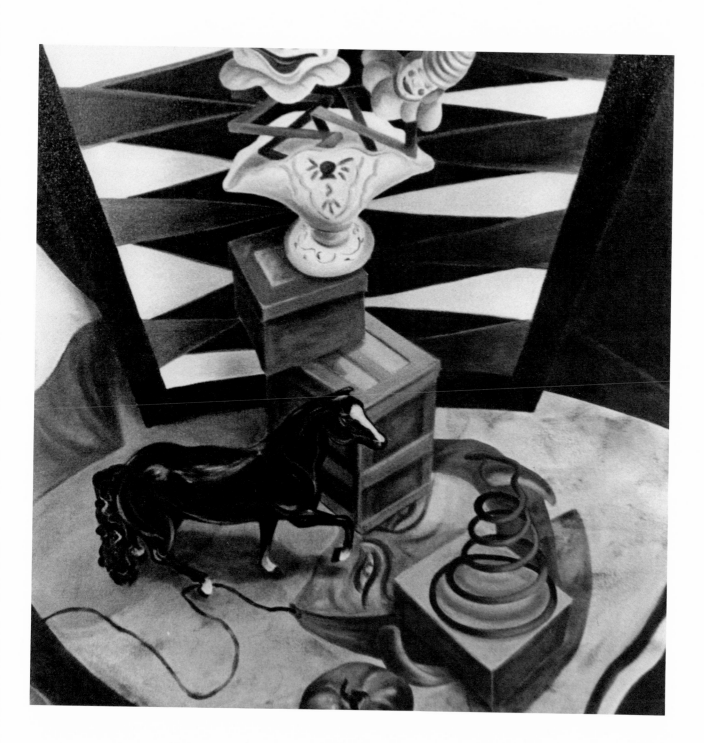

John D. Kehoe

Born Detroit, Michigan, 1927

B.F.A. 1953, Wayne State University, Detroit, Michigan; M.F.A. 1958, University of Michigan, Ann Arbor; Académie Julian, Paris, 1959; Fonderia Bruni/Fonderia Gino, Rome, Italy, 1966

Resides in Athens, Georgia; director, The University of Georgia Studies Abroad Program, Cortona, Italy, and professor, Department of Art, The University of Georgia

Order of Knighthood by the Republic of Italy, 1986; *Gold Medal*, Biennale Internazionale del Bronzetto Dantesco, Ravenna, Italy, 1981; Georgia Governor's Award in the Arts, Georgia Council for the Arts, 1980; Honorary Citizen of Cortona, 1976; Etruscan Academy Honorary Member, Cortona, Italy, 1970

The artists feel as if they are on hallowed ground as they roam through Italy. The inspiration of our predecessors shapes the spirit of our studios. In Cortona I became more attuned to that ambiance and my identity with my own work became more intense. It seemed as if the very air carried new ideas and promise.

Horoscope II 1983
Bronze
19½ x 16 x 4¾

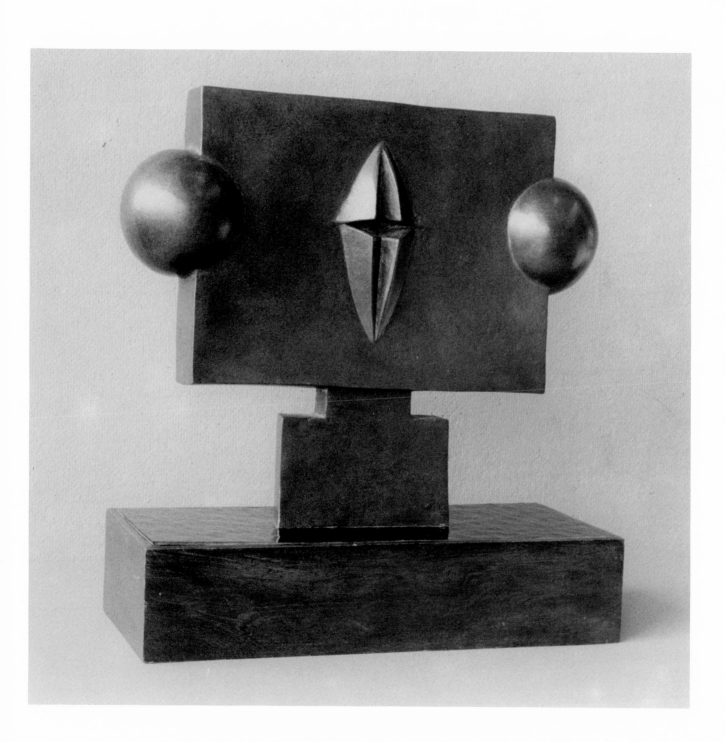

Norman Keller

Born Hollywood, California, 1933

B.F.A. 1961, M.F.A. 1963, The University of Georgia, Athens

Resides in Greenville, North Carolina; professor, School of Art, East Carolina University

Italy and Cortona—they seem to enliven the senses: sight, sound, taste, touch, and, most important, the sense of *real* history and one's relationship to the past, present, and future. It almost seems a test, to come out the other side into a new awareness of one's own dimensions. I recommend it.

Cheops Table—State Two 1988
Plexiglas and brass
23 x 17 x 12

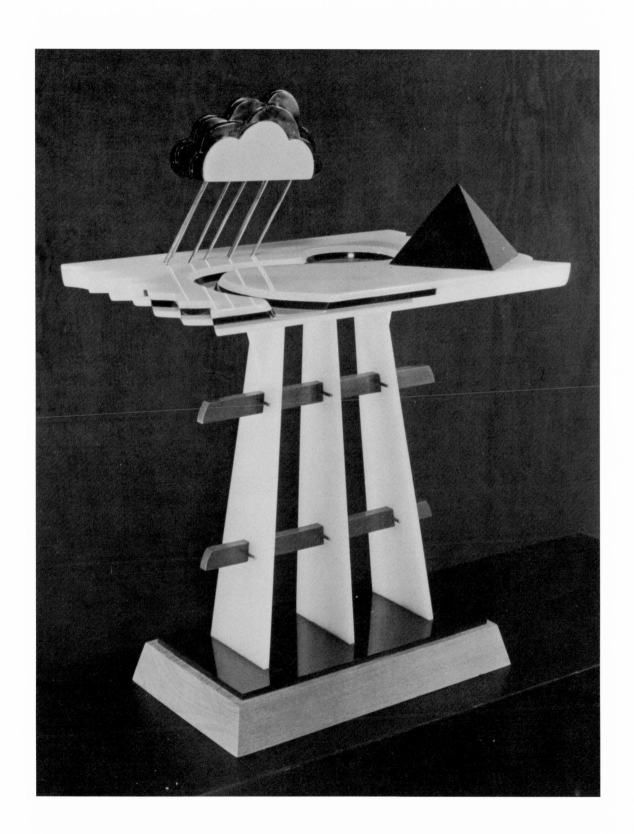

Kenneth A. Kerslake

Born Mount Vernon, New York, 1930

B.F.A. 1955, M.F.A. 1957, University of Illinois, Urbana-Champaign

Resides in Gainesville, Florida; professor, Department of Art, University of Florida

Associated American Artists Gallery Edition Award, Society of American Graphic Artists, *57th National Exhibition*, New York City, 1979; Joseph Pennell Purchase Award, *24th National Exhibition of Prints*, Library of Congress, Washington, D.C., 1976

Cortona and Italy had a profound effect upon my work. In addition to the richness of the art, the warmth of the people and the place inspired a closer look at my immediate world. Memories of the ambiance of the piazza initiated a study of my own small patio as a visual metaphor. This idea, conceived in Cortona during the summer of 1982, continues as a series of prints and paintings of which *Sarah's Garden* is a part.

Sarah's Garden 1987
Intaglio print and lithograph on paper
23¼ x 31½

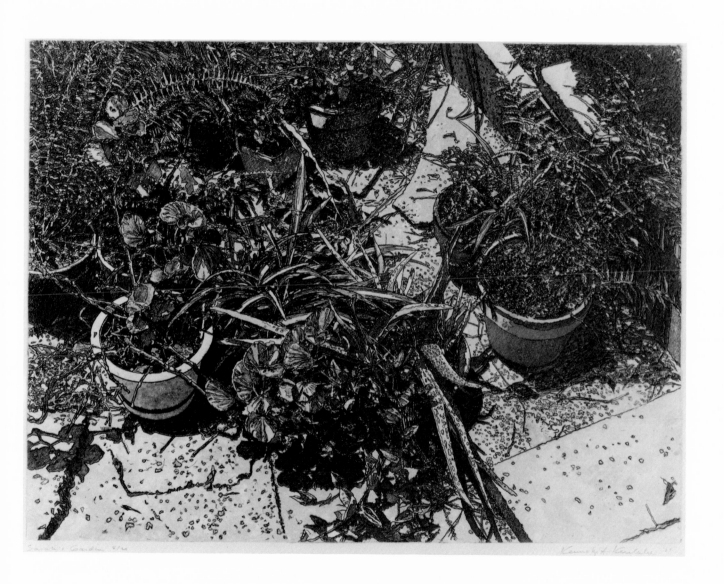

Jack King

Born Memphis, Tennessee, 1948

B.F.A. 1970, University of Tampa, Florida; M.F.A. 1973, The University of Georgia, Athens

Resides in Augusta, Georgia; associate professor, Department of Fine Arts, Augusta College

Louis K. Bell Alumni Award for Research, Augusta College, Augusta, Georgia, 1987

This work was produced, as well as inspired, by my "Italian Experience." As a member of the first fall program, I was fascinated by Cortona's streets and alleys, which in turn influenced my sculpture. I continue to work from sketches made in Italy in 1984.

Vicolli di Cortona: Tempesta Ottobre 1984
Bronze
19½ x 7 x 5

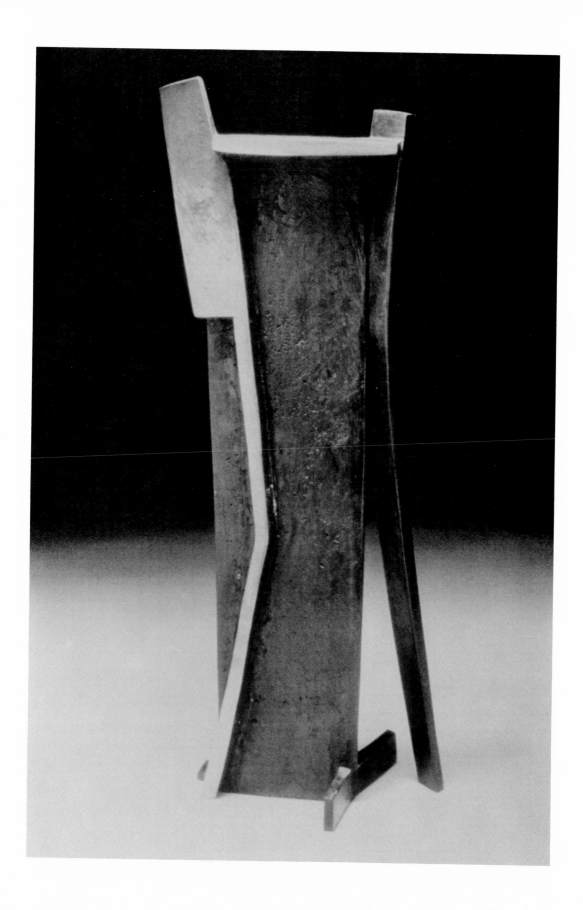

L. Brent Kington

Born Topeka, Kansas, 1934

B.F.A. 1957, University of Kansas, Lawrence; M.F.A. 1961, Cranbrook Academy of Art, Bloomfield Hills, Michigan

Resides in Makanda, Illinois; director and professor, School of Art and Design, Southern Illinois University, Carbondale

Illinois Arts Council Artists Fellowship, 1985; American Crafts Council, Academy of Fellows, 1982; National Endowment for the Arts Visual Arts Fellowship, 1975

I have always been a student and lover of the arts, excited and challenged by works from many periods of time and cultures. My recent work has unquestionably been influenced by my experiences during the summer of 1987 while a guest professor with The University of Georgia Studies Abroad Program in Cortona, Italy. That time allowed me the opportunity for intense study of the great art of Italy, its architecture, painting, sculpture, mosaics, and liturgical objects. Included, of course, are the works of the Etruscans, marked by their wonderful animal and human forms.

My new work has been influenced by all this, as well as by my observation of man's inherent need to explore spiritual questions and to express worship pictorially and through objects of ritual. The title of my sculpture, *Croiser*, is not intended to express a particular religious preference or ritualistic use; rather, it is intended to emphasize man's continuing need to acknowledge a deity, a greater power which brings order, truth, and harmony to what otherwise can appear to be chaos.

Crosier 1988
Forged and polychromed mild steel, gold, and slate
56½ x 5½ x 8

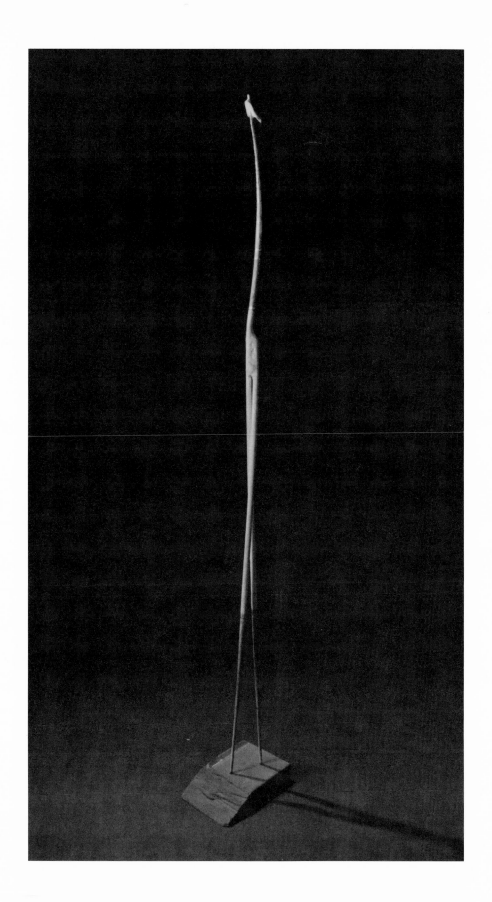

Richard W. Kinnaird

Born Buenos Aires, Argentina,
1931

B.A. 1953, Carleton College,
Northfield, Minnesota; M.F.A.
1958, University of Illinois,
Urbana-Champaign

Resides in Chapel Hill, North Car-
olina; assistant chairman and pro-
fessor, Department of Art,
University of North Carolina

Gold Medal, *40th Annual North
Carolina Artists Exhibition*, North
Carolina Museum of Art, Raleigh,
1977; Purchase Award, *36th An-
nual North Carolina Artists Exhibi-
tion*, North Carolina Museum of
Art, Raleigh, 1973; Purchase
Award, *Northwest Printmakers 30th
International Exhibition*, Seattle,
Washington, 1959; Merit Award,
Chicago Artists Exhibition, Navy
Pier and Art Institute of Chicago,
1957

The character of the work accomplished in Cortona was abstract and reflected indirectly, but significantly, the influence of Cortona.

The space, the light, and the people combined to produce an unforgettable experience. That visit was my first and, so far, only trip to Italy, thus making the meaning primary and intense.

The people of Cortona made working there easy and a pleasure. I realized at the time that this atmosphere was going to affect my work in a very positive way. The most immediate change occurred in color relationships and, later, shapes. These changes reduced the severity of my abstract work, making its character more human.

Title Search 1988
Acrylic on wood
48 x 48

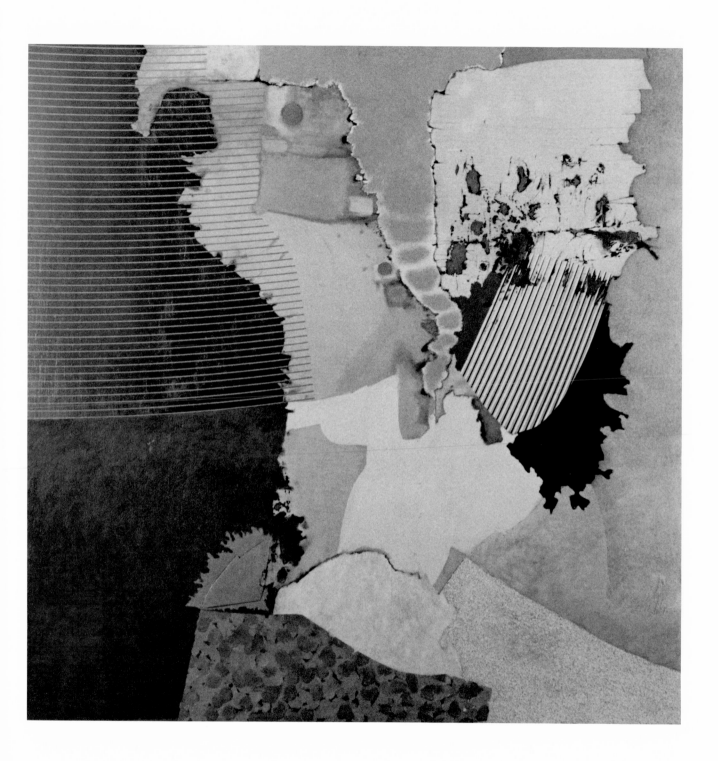

William J. Kitchens

Born Fort Bragg, North Carolina, 1951

B.F.A. 1975, Virginia Commonwealth University, Richmond; M.F.A. 1984, The University of Georgia, Athens

Resides in New Orleans, Louisiana; assistant professor, Department of Visual Arts, Loyola University

Cash Award, *First Annual Works on Paper Exhibition*, University of Texas at Tyler, 1986; Purchase Award, *Sixth Alabama Works on Paper Exhibition*, Auburn University, Auburn, Alabama, 1985; Cash Award, *Chautauqua 27th National Exhibition*, Chatauqua, New York, 1984; Purchase Award, *National Print Competition 83*, Edinboro College, Edinboro, Pennsylvania, 1983

The late Mike Nicholson in a lecture once said, "If I get to heaven and Cortona is not there, I will be terribly disappointed." I'm sure he's there now with the pitiful one-eared cat he described so vividly in one of his poems.

I have always imagined heaven to be an endless series of perfect moments, one after another. One image of Cortona that recurs most frequently to me, usually in that image-rich brain activity just before sleep, is that of an early morning flock of swallows silhouetted against a valley fog bank. Sure, it sounds clichéd and shallow, but it was a perfect moment nonetheless.

Animus 1986
Intaglio print on paper
9 x 12

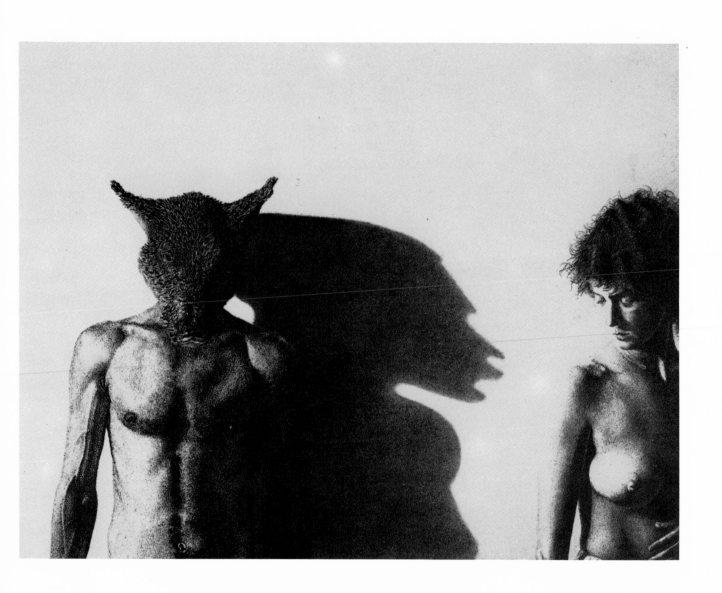

Andrew Krieger

Born New York City, 1950

B.A. 1972, Windham College, Putney, Vermont; M.F.A. 1979, The University of Georgia, Athens

Resides in Washington, D.C.; museum specialist, National Gallery of Art

As an artist I find travel and exposure to different cultures particularly stimulating. Contact with different environments causes a reaction in my system which strongly affects the way I interpret my ideas.

I find the environment in Italy, and specifically Cortona, to be one that has been particularly stimulating to me and has affected the perspective I have as an artist.

Study for Walking Forms 1987
Graphite and ink on paper
8 x 10

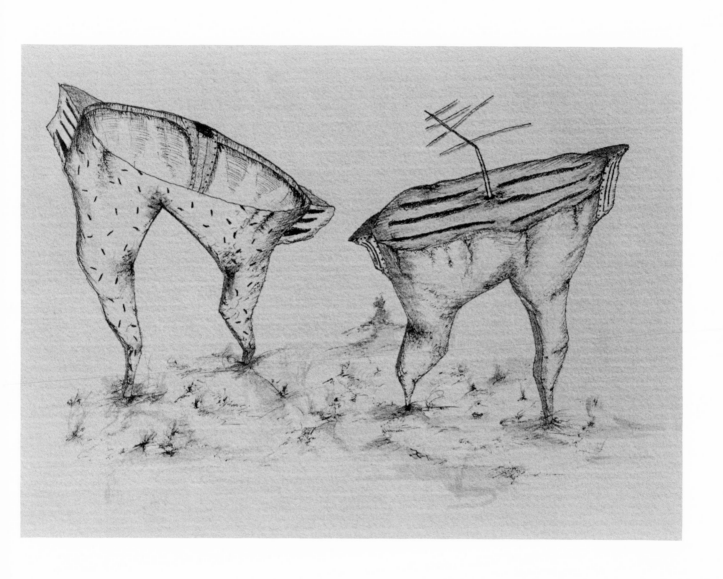

John Lawrence

Born Columbus, Mississippi, 1943

B.F.A. 1967, Atlanta College of Art; M.F.A. 1970, Tulane University, New Orleans, Louisiana

Resides in LaGrange, Georgia; chairman and professor, Department of Art; director, Lamar Dodd Art Center; LaGrange College

This photograph at the entrance into the park of Cortona I made early one morning just as the sun was coming up. I particularly enjoyed the early morning light of Italy.

The photograph also sums up, for me, the visual richness of Italy—the contrasts of shapes and textures of stone, wood and foliage. It also exemplifies Cortona herself—the uphill walks, the various directions you could take, and Bacchus, the ancient god of sensuality and wine, who beckons you back.

First Light—Cortona 1984
Gelatin silver print
20 x 24

Jackson Pittman Lewis

Born Wilmington, North Carolina,
1945

B.F.A. 1970, East Carolina University, Greenville, North Carolina;
M.F.A. 1972, The University of
Georgia, Athens

Resides in Ruston, Louisiana;
associate professor, School of Art
and Architecture, Louisiana Tech
University

Outstanding Researcher Award,
College of Arts & Sciences, Louisiana Tech University, 1987-1988

My Cortona adventure in the summer of 1971 was and remains one of my richest artistic experiences. At that time it opened up to me a wealth of Western culture which continues to influence both my thought and artistic efforts.

Reclining Blade 1985
Marble and wood
48 x 12 x 12

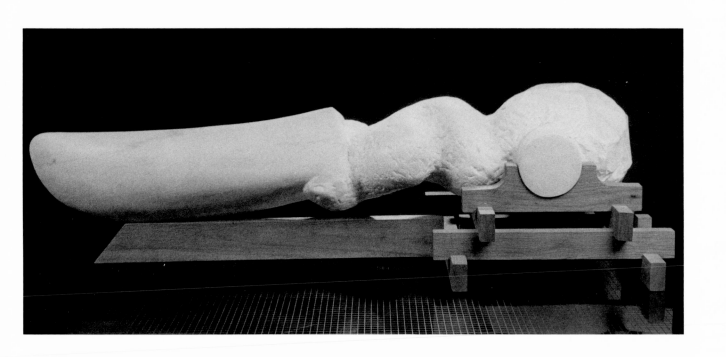

Nancy Lloyd

Born Alice, Texas, 1948

B.A. 1971, Adams State College of
Colorado, Alamosa; M.Ed. 1978,
University of North Carolina,
Greensboro

Resides in Athens, Georgia; art in-
structor, Athens Academy

I always think of Cortona as a turning point in my approach to
watercolor. Free from the daily intrusions and responsibilities of
home it gave me the opportunity to work. It also provided the
environment for continual inspiration and the students to keep
me challenged. As I began to fully appreciate the light, the
colors, and the mood of Cortona, my palette changed, my ap-
plication changed, and my sensitivity toward the media
changed. To go back is to refresh the eyes, the mind, and the
spirit.

Winter Fields 1988
Watercolor on paper
27½ x 34½

David Lund

Born New York City, 1925

B.A. 1948, Queens College, New York City

Resides in New York City; artist

Hassam Fund Purchase Awards, American Academy of Arts and Letters, 1969, 1978; *National Collection of Fine Arts Exhibition*, White House, Washington, D.C., 1966-1969; Art in Embassies Program, U.S. State Department, 1966-1967; Ford Foundation Purchase, 1961; Fulbright Grants, Rome, Italy, 1957-1958, 1958-1959

Once again, after an absence of many years, I had returned to Italy—this time to Cortona in the summer of 1984. As in my previous visit, this stay was to have a powerful and lasting effect upon my work. Developments in my painting which were already in progress were greatly intensified by contact with the deep sources and currents of Italian art, discovering in them—again—elements so parallel to my own concerns. What made the experience so tangible were the intimate and everyday encounters with the life and people of Cortona, the walks through its ancient streets and along its ramparts, the feel of the stones in its walls and piazzas, and the olive and vineyard terraced slopes, all saturated with their special light. These have remained with me.

Tuscan Village 1986
Pastel on paper
22½ x 30
Courtesy Grace Borgenicht Gallery, New York City

Joni Mabe

Born Atlanta, Georgia, 1957

B.F.A. 1981; M.F.A. 1983, The
University of Georgia, Athens

Resides in Athens, Georgia; artist

SECCA/RJR Southeastern Artists
Fellowship, Winston-Salem, North
Carolina 1987-88; Franklin Fur-
nace Exhibition Series, New York
City, 1987-88; Nexus Press Artists'
Book Residency, Atlanta, 1985,
1987; M.F.A. Ford Foundation
Grant, 1983; M.F.A. Ford Founda-
tion Fellowship, 1981

Cortona was like finding yourself in a Fantasy Land at Disney
World, but knowing it's the real thing.

The Official Elvis Prayer Rug 1988
Lithograph on paper
24½ x 34½

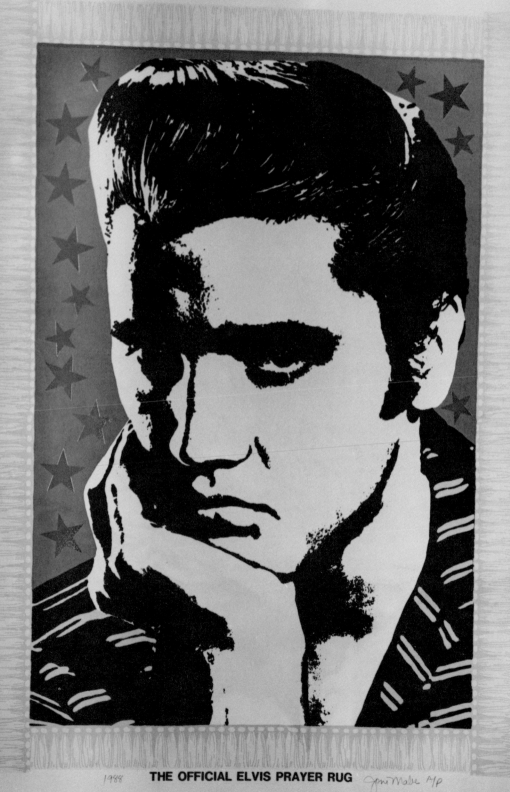

1988 **THE OFFICIAL ELVIS PRAYER RUG** *Jon Mole A/P*

Charles Massey Jr.

Born Lebanon, Tennessee, 1942

B.S. 1964, Middle Tennessee State University, Murfreesboro; M.F.A. 1972, The University of Georgia, Athens

Resides in Columbus, Ohio; professor, Department of Art, The Ohio State University

National Endowment for the Arts Visual Artists Fellowship, 1982; Ohio Arts Council Individual Artist Fellowship, 1981, 1986

I was a graduate student participating in the first Cortona program in 1970. I was invited back in 1979 and again in 1985. I look forward to the time I will be able to return.

My work seeks vision in uncovering magic and spirit, the soul present in everything. Cortona—and Italy—provide me with a major component in my work, in my life. One might not be able to see it concisely, saying that something equals a visual symbol. But everything matters to me; all experiences are important. They become inherent, imbedded in the crevices of my mind and my feelings. A trip to Cortona in 1970 charged my life and my work forever; it broadened my world, my understanding and made me know that ideals, that answers, were possible, if we could see well enough. Cortona is a place in the world that clears vision.

Vision Bridge, ACH Secret 1987
Lithograph
20 x 15

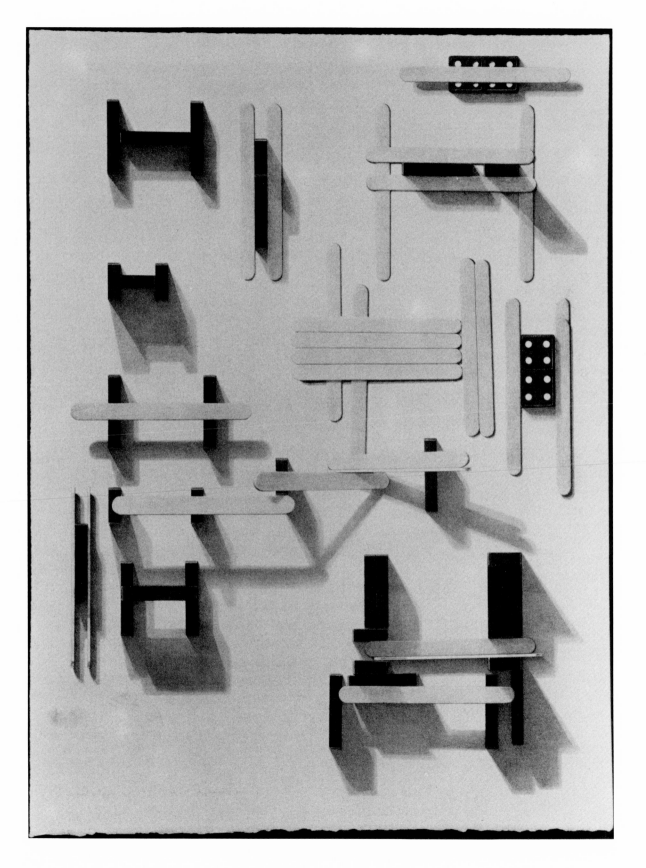

Terry S. McGehee

Born Marianna, Florida, 1949

B.A. 1971, Queen's College;
M.F.A. 1974, Washington University, St. Louis, Missouri

Resides in Decatur, Georgia; chairman, Department of Art, Agnes Scott College

Purchase Award, Albany Museum of Art, Albany, Georgia, 1981; Fulbright/Hayes Grant for study in India, 1978; Cosa di Risparmio de Firenze Award, Cortona, Italy, 1975

I am charged by nature. There is nothing more honest than
 natural forces.
Landscape is the metaphor for my grounding.
Marks are my energy.
Colors are my spirit.
Sharing is my love.
These things describe Cortona.

Diamond in the Rough 1987
Pastel and graphite on paper
42 x 34

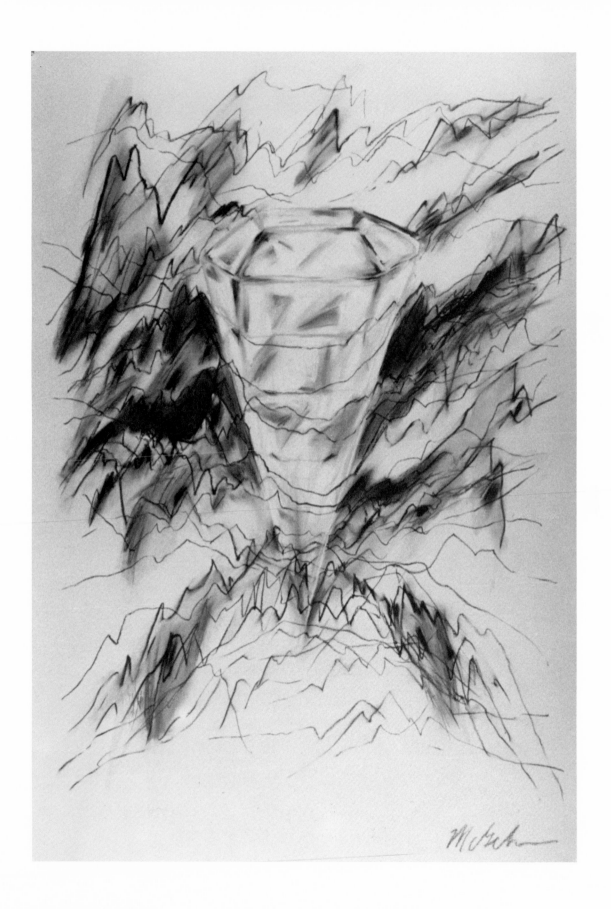

James Albert McLean

Born Gibsland, Louisiana, 1928

B.A. 1950, Southwestern Louisiana
Institute; B.D. 1953, Southern
Methodist University, Dallas, Texas;
M.F.A. 1961, Tulane University,
New Orleans, Louisiana

Resides in Atlanta; professor,
School of Art and Design, Georgia
State University

Purchase Award, Huntsville Mu-
seum of Art, *Southeastern Invita-
tional Print Exhibition*, Huntsville,
Alabama, 1980; Purchase Awards,
*Minot State College National Print
and Drawing Exhibition*, Minot,
North Dakota, 1973, 1975; Pur-
chase Award, *Boston Printmakers
National*, Boston, Massachusetts,
1967; Purchase Award, *Auburn
University National Print Exhibition*,
Auburn, Alabama, 1965; Merit
Award, Arts Festival of Atlanta,
Atlanta, Georgia, 1964; Purchase
Award, *Wesleyan College National
Print and Drawing Exhibition*,
Macon, Georgia, 1964

After spending most of my adult life viewing Italian art
through the "peephole" of slides and book illustrations, I was
absolutely stunned by the visual richness of the Italian experi-
ence: the geography, the people, seeing a cultural heritage
firsthand and in some kind of human context. At first I was
overwhelmed and almost incapacitated by it, but this rich expe-
rience gradually provoked me to creative acts of my own. The
memories and after-images continue to nurture such acts.

Bits and Pieces I 1987
Silkscreen on paper
5 x 5¼

Judith McWillie

Born Memphis, Tennessee, 1946

B.F.A. 1969, Memphis State University, Memphis, Tennessee; M.F.A. 1971, The Ohio State University, Columbus

Resides in Athens, Georgia; associate professor, Department of Art, The University of Georgia

University of Georgia Senior Faculty Fellowship in the Fine Arts, 1988; Southern Arts Federation/ National Endowment for the Arts Fellowship in Painting, 1986

Working and teaching in Cortona, 1976-1977, helped me understand the powerful continuity that exists between Europe and the United States. The sense of tradition was heightened and I also became more aware than ever of how revolutionary modernism had actually been. In the years since, because of that experience, I have been better able to discern comparisons and contrasts in Western and non-Western art and philosophy.

The Body is the Crossroads 1987
Acrylic and paint shards on wood
69 x 51

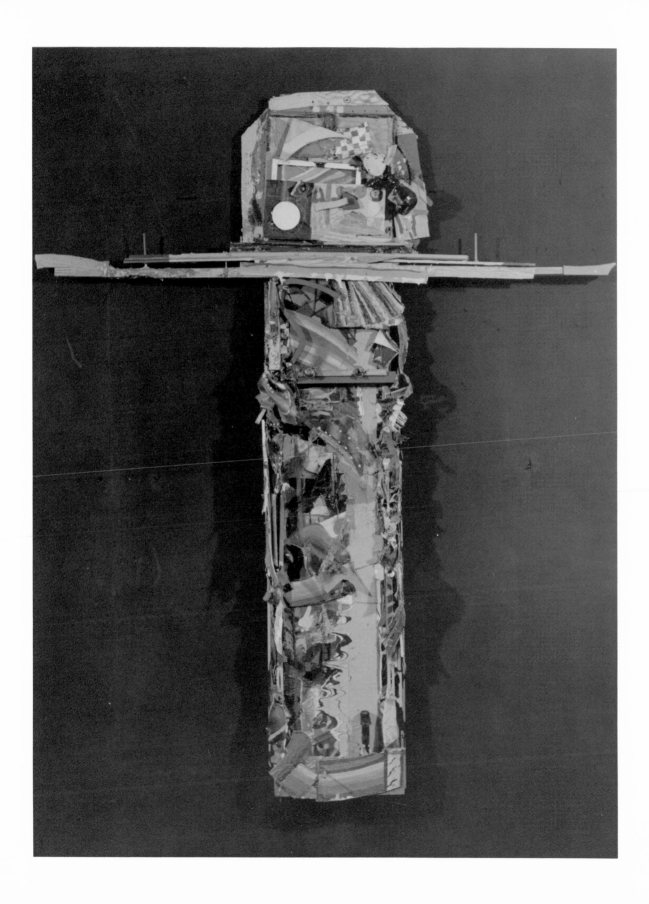

Ted Metz

Born Columbus, Ohio, 1949

B.F.A. 1971, Old Dominion University, Norfolk, Virginia; M.F.A. 1973, University of South Carolina, Columbia

Resides in Montevallo, Alabama; professor, Department of Art, University of Montevallo

Alabama State Arts Council Visual Artists Fellowship, 1986; National Endowment for the Arts Building Arts Grant, 1982

The distinctive beauty of Cortona and its surrounding environs is matched only by its inhabitants. I have found inspiration for my sculpture in my memories of the people and the places.

Stress Fault 1987
Steel and cast earth
14 x 22 x 6

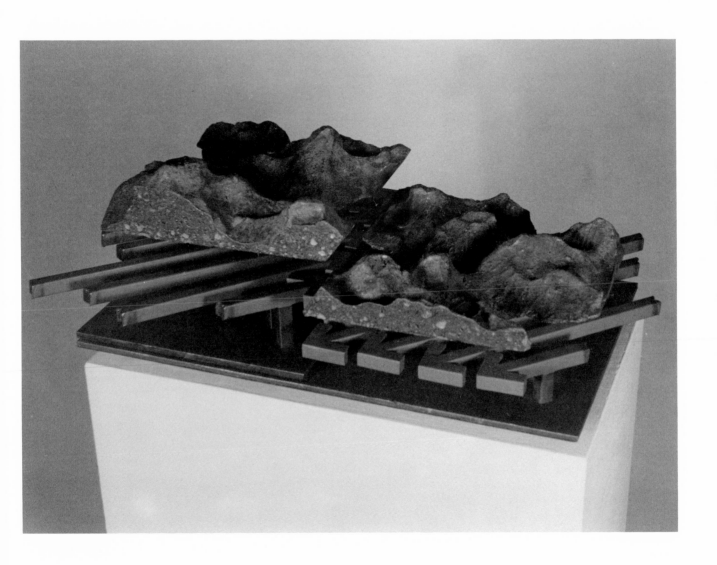

Ronald Meyers

Born Buffalo, New York, 1934

B.S. 1956, M.S. 1961, State University College at Buffalo, New York; M.F.A. 1967, Rochester Institute of Technology, Rochester, New York

Resides in Athens, Georgia; associate professor, Department of Art, The University of Georgia

Artist Residency Award, Penland School of Arts and Crafts, Penland, North Carolina, 1986; Summer Research Grants, The University of Georgia, Athens, 1981-1982; Honorable Mention, *Las Vegas National Print Exhibition*, Las Vegas, Nevada, 1971; Best of Show, *Mid-South Ceramic and Crafts Exhibition*, Middle Tennessee State University, Murfreesboro, 1971; Research Grant, University of South Carolina, Spartanburg, 1970; Purchase Award, *Mid-South Ceramic and Crafts Exhibition*, Middle Tennessee State University, Murfreesboro, 1969

Covered Jar 1988
Ceramic
14 x 9

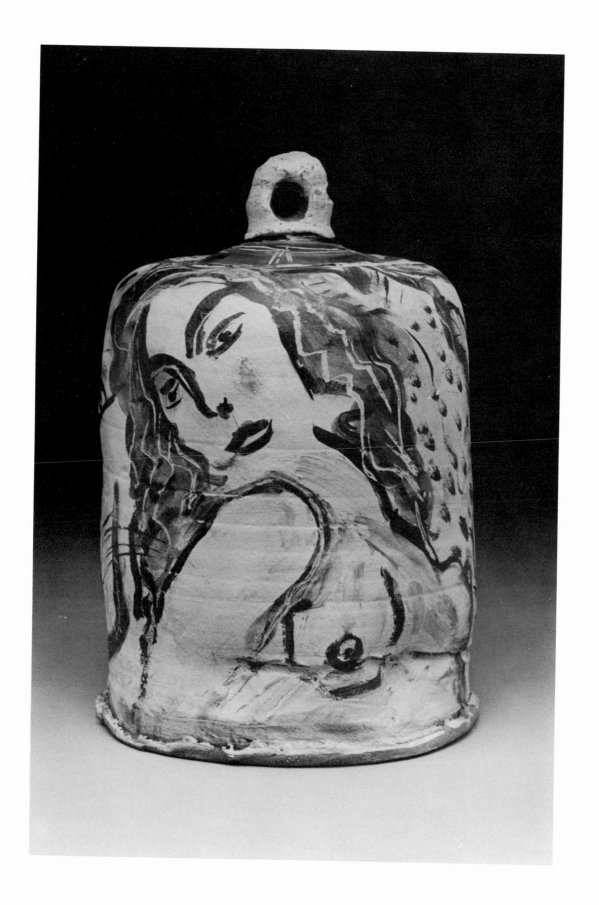

Larry Millard

Born Bristol, Virginia, 1950

B.F.A. 1972, East Tennessee State University, Johnson City; M.F.A. 1975, Washington University, St. Louis, Missouri

Resides in Athens, Georgia; associate professor, Department of Art, The University of Georgia

The General Sandy Beaver Associate Professorship, Franklin College of Arts and Sciences, The University of Georgia, Athens, fall 1988-spring 1991; Faculty Research Grants, The University of Georgia, 1987, 1986, 1983, 1978; National Endowment for the Arts Art in Public Places Grant, Arts Festival of Atlanta, Atlanta, Georgia,1984; Ford Foundation Faculty Enrichment Grant, The University of Georgia, 1979

Cortona is simply a beautiful city that offers a very special experience for all who go there. It is an early Etruscan town with a winding composition of streets and buildings that hug the mountain. The rich order and texture that have evolved with the city are profound as a stimulus for me as an artist.

The opportunity to participate as an artist-in-residence and as a faculty member allowed me to see parts of Europe, Italy, and Cortona in ways I would never have had as an individual. Students, faculty, and artists-in-residence share in an experience unequaled by any other circumstance. I am very proud to have participated in 1979 and 1984.

The ideas behind the small glass work in this exhibition are a result of many of the experiences I have had and many things I have seen in Italy while working in Cortona.

Column Section 1988
Glass, aluminum, adhesive, and glass beads
27 x 6 x 4½

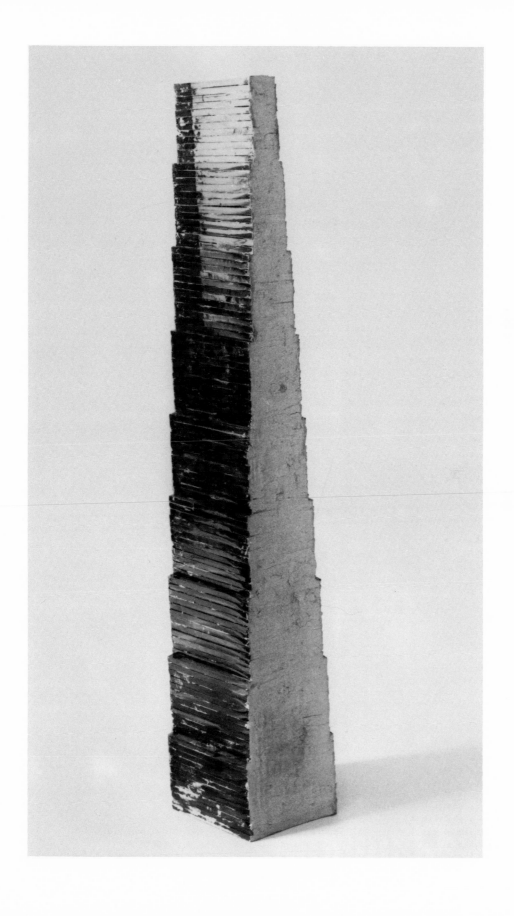

Mary Ruth Moore

Born Farmington, Georgia, 1936

B.A. 1957, University of Montevallo, Montevallo, Alabama; M.A.Ed. 1970, The University of Georgia, Athens

Resides in Athens, Georgia; instructor, Department of Art, The University of Georgia

I have spent some of my happiest and most fulfilling moments with my pinhole camera, rambling in and around Cortona, Italy. There is a thoughtful and deliberate pace, with not much regard for our usual attitude toward time, but at the same time there is a pervasive genuine vitality. Each stone and corridor seems alive with its own special presence. Perhaps it's the luminous haze of light, revealing a patina rich from centuries of care and wear. Perhaps the Italian tendency to embrace all that life offers is contagious. I don't really know what makes the magic, but it continues...

The Elegant Chair 1986
Pinhole camera photograph, gelatin silver print
12 x 6

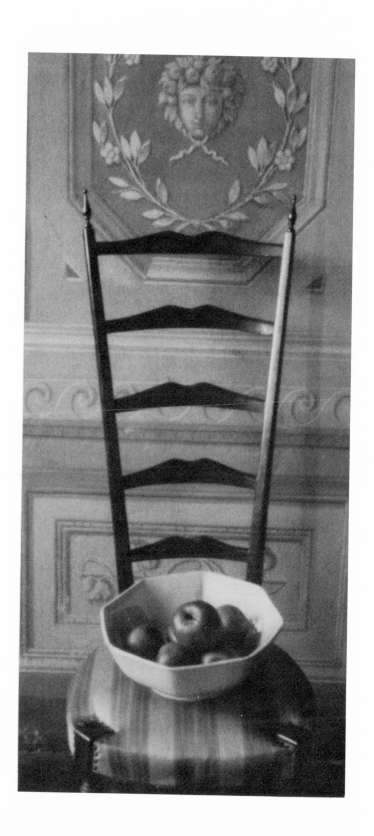

Charles Morgan

Born Doucette, Texas, 1927

B.S. 1952, University of Texas at Austin; M.F.A. 1956, University of Colorado, Boulder

Resides in Athens, Georgia; associate professor, Department of Art, The University of Georgia

Ford Foundation Grant to study in Holland, Belgium, and Italy, 1980; Grant, Center for the Book Arts, New York City, 1977; Carnegie Foundation Grants for study of printmaking facilities and programs in United States and England, 1968

Untitled 1988
Handmade book, watercolor and graphite on paper
7¼ x 6 x 1

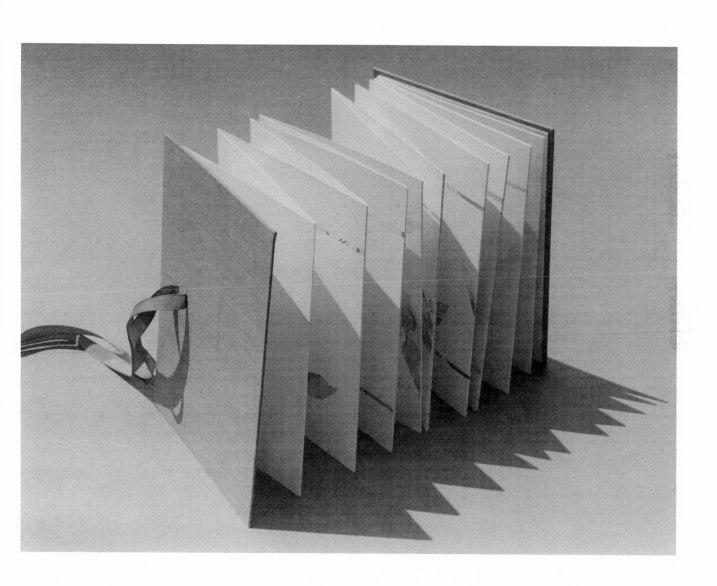

Angelo Moriconi

Born Foligno, Italy, 1932; died
1977

Belle Arti Certificate, Art Academy,
Perugia, Italy

Angelo Moriconi, a native of the region of Umbria, taught
painting and drawing the first two years of the Studies Abroad
Program in Cortona. His work included painting and prints.
He utilized a fresh palette of colors in this drawing, which was
inspired by both the soft profile of the hills of his native region
and the capital M initial of his last name as he signed it.

Untitled 1971
Pastel on paper
32½ x 25
Collection of Aurelia Ghezzi

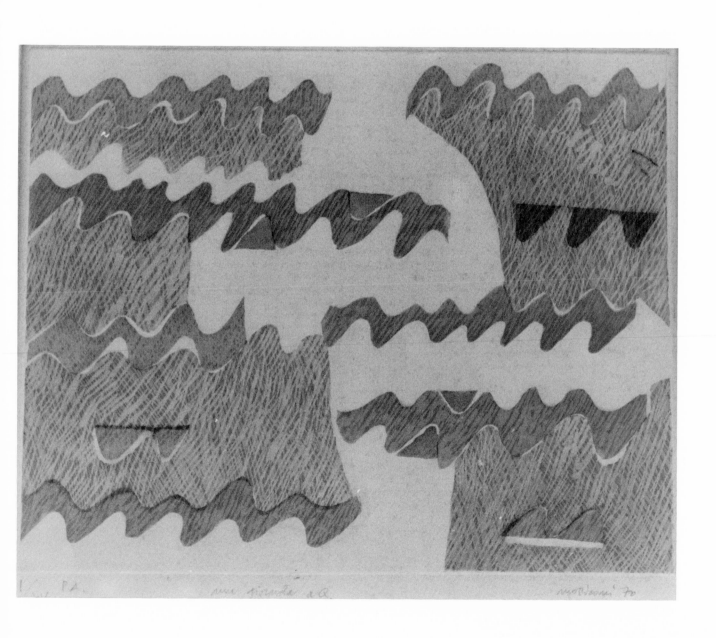

una risata a Q. mattiacci 70

Andy Nasisse

Born Pueblo, Colorado, 1946

B.F.A. 1969, Adams State College
of Colorado, Alamosa; M.F.A.
1973, University of Colorado,
Boulder

Resides in Athens, Georgia; professor, Department of Art, The University of Georgia

Research Medal, The University of
Georgia, 1981; NEA/SECCA
Southeastern Artists Fellowship,
1977

Libation Lamentation is meant to reflect the way images and influences enter our senses from anywhere and everywhere and form a mental conglomerate of stratified meanings. Ultimately we have to act through these surface images to allow light to enter into the darkness of the internal volume. Some of the images are taken from my personal experiences in visiting Italy.

Libation Lamentation 1987
Ceramic
17 x 27 x 9

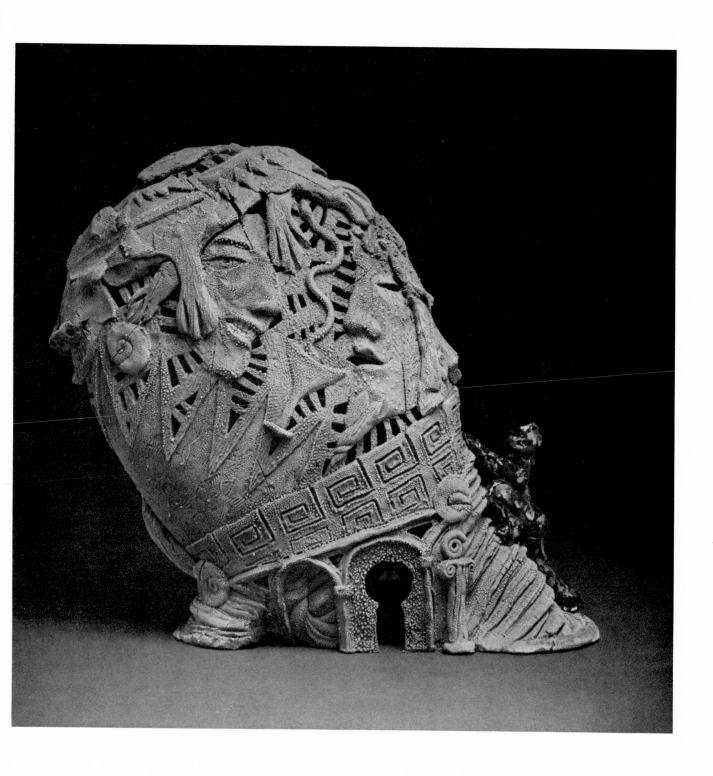

Mike Nicholson

Born Henderson, North Carolina,
1936; died 1987

B.A. 1965, Florida State University,
Tallahassee; M.F.A. 1967, University
of North Carolina at Greensboro

Everytime you look around [Cortona], you realize it is a very sensual world. Everything is immediately tactile, like that ancient stone wall with clumps of grass. I found little images getting into my paintings, little variations, little bits and pieces. This whole process beginning with those little fragments has continued to expand.

From *UGA Research Reporter*, 1982

Untitled 1985
Collage and acrylic on canvas
22 x 26
Collection of Tanna Nicholson

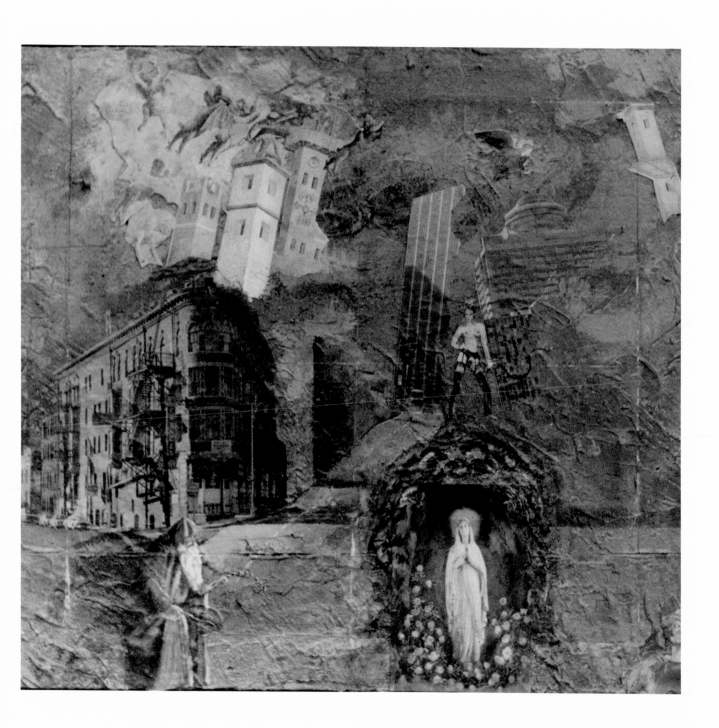

Robert Nix

Born North Vernon, Indiana, 1934

B.S. 1954, M.A.Ed. 1955, Ed.S. 1963, Ed.D. 1968, The University of Georgia, Athens

Resides in Athens, Georgia; professor, Department of Art, The University of Georgia

Mentor, Lilly Fellowship Holders, The University of Georgia, Athens, 1986-1987; The General Sandy Beaver Professorship, Franklin College of Arts and Sciences, The University of Georgia, fall 1982-spring 1985; Educator of the Year, National Art Education Association, 1984; Award, Special Contribution to The University of Georgia Office of Institutional Research and Planning, 1984

The Cortona program, for me, was all too brief but my experiences were part of something which I sensed almost immediately as being timeless: a small segment of a continuum relating to man and his existence in one given place. Everywhere I looked in Italy there were monuments and museums which attested to the height of man's creative genius. In this charged atmosphere one can become caught up with a sense of confidence in being a part of this great creative heritage. It is as though you are compelled to get on with your work. It was, however, in the hill country in and around Cortona that I found an environment which I felt I could respond to with some degree of credibility. Here there were subjects I understood: dazzling light and a timeless sense of human presence on the land. There were vineyards, gardens, terraces, paths, pastures, woods, dwellings, and shrines; but underneath it all there was the land—the hills and the valley below. Here countless crops had grown, flowers had bloomed, and buildings had been built, often with the stones of previous structures. Somehow it seemed appropriate to photograph those simple subjects which are so elemental to that enduring historic place. Today, I approach whatever place I am in with an added sense of respect for its unique, though perhaps simple, significance.

Hillside Garden 1984
Gelatin silver print
9 x 13

Gary Noffke

Born Decatur, Illinois, 1943

B.S. 1965, M.S. 1966, Eastern Illinois University, Charleston; M.F.A. 1967, Southern Illinois University, Carbondale

Resides in Athens, Georgia; professor, Department of Art, The University of Georgia

Honorable Mention, *Second Biennal Lake Superior National Crafts Exhibition*, University of Wisconsin, Superior Tweed Museum, Duluth, Minnesota, 1972; First Place in Jewelry and Metal; Best-in-Show Award, St. Augustine Annual Arts and Crafts Festival, St. Augustine, Florida, 1971; Purchase Award and Honorable Mention, *Eighth Annual Piedmont Crafts Exhibition*, Mint Museum, Charlotte, North Carolina, 1971; Cash Award, *Twentieth Florida Craftsman Exhibition*, Sarasota Art Association, Sarasota, Florida, 1970; Special Recognition and Purchase Award, *Seventh Annual Piedmont Crafts Exhibition*, Mint Museum of Art Charlotte, North Carolina, 1970; and numerous invitational exhibitions, lectures, panels, and workshops

My experiences in Italy greatly contributed to my understanding of the history of silver and goldsmithing. I attempt to make objects that reflect the rich traditions of the materials and techniques rather than the trend of the day.

Two Cups 1988
Sterling silver with gold alloys
2½ x 5½ , 3 x 7

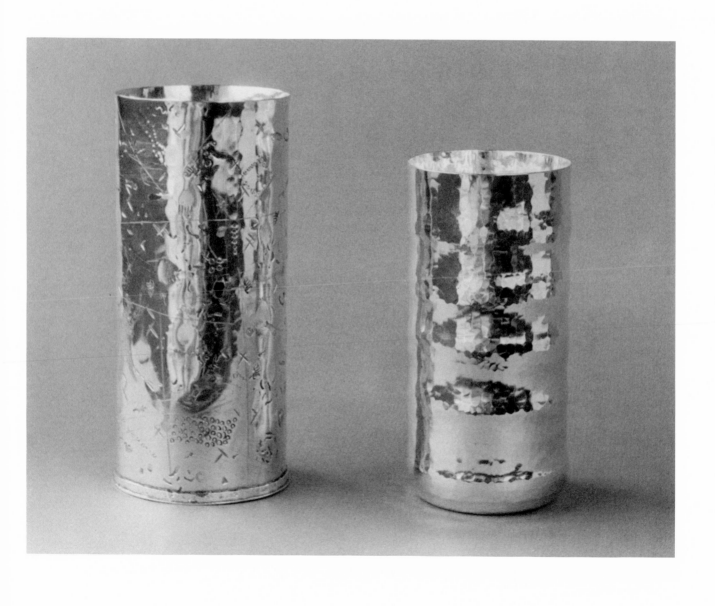

Dennis Olsen

Born Springfield, Illinois, 1941

B.A. 1964, M.A. 1967, University of California at Los Angeles

Resides in San Antonio, Texas; associate professor, Division of Art and Design, The University of Texas at San Antonio; co-founder and director, Santa Reparata Graphic Art Centre, Florence, Italy

Purchase Award, *Sixteenth National Works on Paper Exhibition*, Minot State College, Minot, North Dakota, 1986; Fulbright Grant for study in Italy, 1967; Purchase Award, *Fifteenth National Print Exhibition*, Brooklyn Museum, Brooklyn, New York, 1966; Award, *Second International Miniature Print Exhibition*, Pratt Graphics Center, New York City, 1966

My first visit to Cortona and to the UGA program was in 1975 when I gave a talk on prints and drawings. Since that time, I have returned twelve times to conduct workshops, lectures, and once to teach for the whole summer. To return there each year is a pleasure and a stimulating professional experience because the atmosphere is charged with excitement. The mix of "old timers," like myself, with people who are seeing Italy for the first time is wonderfully healthy and produces the "esprit de corps" of which The University of Georgia is justly proud. The impact that the Tuscan landscape has had on my work—especially in recent years—has been enormous. In Cortona the spectacular blend of architecture spilling down the precipitous hillside and overlooking the broad expanse of the Val di Chiana below has often entered my prints and drawings. My monotype in this exhibition, though not directly inspired by Cortona, could well have borne a Cortonese title for the very qualities that I have just mentioned.

Castiglioncello IX 1988
Monotype on paper
11½ x 35½

Maxine Olson

Born Kingsburg, California, 1931

B.A. 1973, M.A. 1975, California State University at Fresno

Resides in Athens, Georgia; assistant professor, Department of Art, The University of Georgia

I was painting professor from The University of Georgia Department of Art during the summer of 1987. The whole experience, including the travel through London and major parts of Italy, provided an opportunity to see many wonderful works of art. Being a figurative painter, the exposure to these works of art was invaluable visually, intellectually, and spiritually.

Aurelia (Maesta) 1988
Oil on canvas
40 x 32
Collection of Aurelia Ghezzi

Herb Parker

Born Elizabeth City, North Carolina, 1953

B.F.A. 1978, M.F.A. 1983, East Carolina University, Greenville, North Carolina

Resides in New Orleans, Louisiana; visiting professor, Department of Art, Newcomb College, Tulane University

While it is difficult to attribute development in one's work to any specific experience, the opportunity afforded me by the Cortona program is an exception. A sense of history permeates its society. That essence has had a significant impact on my environmental installations. An historical perspective is suggested through the material as well as an archaic architectonic formalism which serves to establish a cultural and historical interaction with the environment.

Shrine #18 1988
Mixed media
61 x 9 x 5

Janice Pittsley

Born Pontiac, Michigan, 1955

B.A. 1977, University of North Carolina, Chapel Hill; M.F.A. 1980, The University of Georgia, Athens

Resides in Tempe, Arizona; associate professor of art, School of Art, Arizona State University

Second Place, *First International Mini-Print Exhibition*, The Studio School and Art Gallery, Johnson City, New York, 1986; Purchase Award, *Hoyt National Drawing and Painting Show*, Hoyt Institute of Fine Arts, New Castle, Pennsylvania, 1985; Dean's Incentive Grant, College of Arts and Sciences, Oklahoma State University, Stillwater, Oklahoma, 1985; Ford Foundation Fellowship, Junior Artist-in-Residence, The University of Georgia, Athens, 1981; Purchase Award, Greenville County Museum of Art, Greenville, South Carolina, 1979; Ford Foundation Fellowships, The University of Georgia Studies Abroad Program, Cortona, Italy, 1978-1979; Purchase Award, William Ackland Memorial Art Center, Chapel Hill, North Carolina, 1977.

Two consecutive summers in Cortona as a graduate student formed the foundation of my work as an artist and teacher. I experienced a link to the past through Italian Renaissance art that continues to provide me with inspiration and encouragement. The landscape of Tuscany had an immediate influence on the use of space, light, and color in my work. Shared experiences with artists and students participating in the Studies Abroad Program formed lasting friendships that I cherish. The travel, work, and happiness of those summers are strong in memory and remain invaluable as a resource for me personally and artistically.

Frieze I 1984
Graphite on paper
20 x 27

Rudy Pozzatti

Born Telluride, Colorado, 1925

B.F.A. 1948, M.F.A. 1950, University of Colorado, Boulder

Resides in Bloomington, Indiana; Distinguished Professor, School of Fine Arts, Indiana University; director, *Echo Press*

Guggenheim Fellowship, 1963-1964; Fulbright Grant for study in Italy, 1952-1953

I was invited by The University of Georgia to teach in the Cortona program in the summer of 1987 and welcomed the opportunity to return to Italy. My feelings for Italy are deep-rooted as both my mother and father were born, and spent their early, formative years, in Italy. The summer of 1987 in Cortona marked my fifth trip to Italy, commencing with a Fulbright grant in 1952, a Guggenheim Fellowship in 1963, and summer teaching appointments in Florence in 1967 and Massa Carrara in 1974. As on all other occasions in Italy, the summer in Cortona presented much subject matter for new work and in particular evoked renewed interest in the Etruscan lore of the region which had been the center of my work during the Guggenheim year and for some time later. I am just now realizing a fruitful period of work brought forth by the summer experience in Cortona.

Remembrances of Cortona 1988
Mixed media and collage on paper
30 x 21

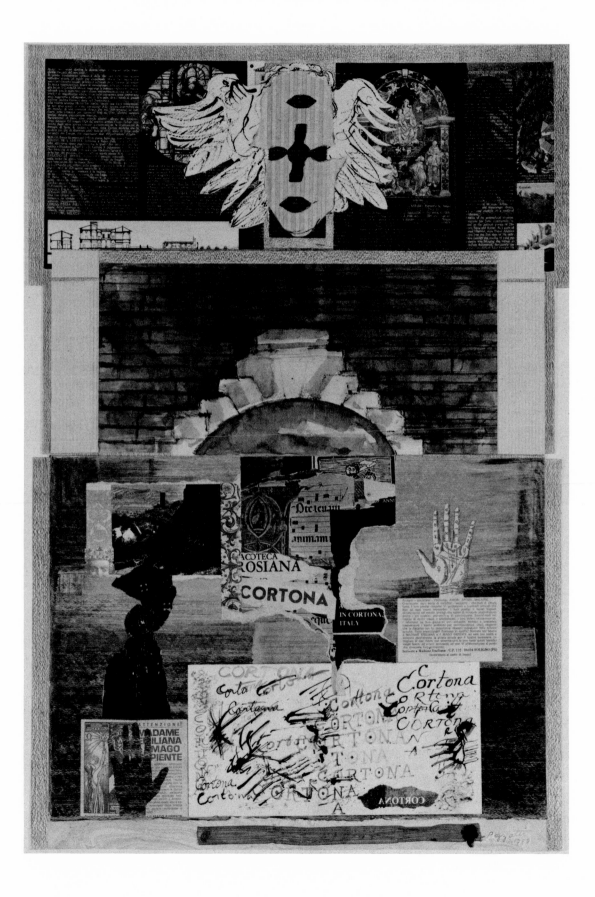

Robert H. Rivers Jr.

Born Anniston, Alabama, 1950

B.F.A. 1973, Auburn University, Auburn, Alabama; M.F.A. 1977, The University of Georgia, Athens

Resides in Orlando, Florida; associate professor, Department of Art, University of Central Florida

Honorable Mention, *Annual Juried Exhibition*, Orlando Museum of Art, Orlando, Florida, 1987; Outstanding Merit Awards for Teaching and Professional Activities, University of Central Florida, Orlando, 1982-1988, 1986-1987; Jurors' Commendation, *38th North American Print Exhibition*, Emmanuel College, Boston, Massachusetts, 1986; Research Grant, University of Central Florida, Orlando, 1986; Special Merit Award for Teaching and Professional Activities, University of Wisconsin-Superior, 1979-1980; Purchase Award, *21st North Dakota Print and Drawing Annual Exhibition*, University of North Dakota Art Galleries, Grand Forks, 1978; Ford Foundation Fellowship, The University of Georgia, Athens, 1977; Purchase Award, United States Information Agency, 1973

The Cortona experience is deeply etched into every person that takes part in the program. Whether they feel they had a "good time" or "learned a lot," the real value lies much deeper. It is a part of the person, whether he or she realizes it or not—and if the person is truly lucky, it may manifest itself in his or her own work. To paraphrase something I overheard, "One does not pick weeds when walking through a garden."

War Prayer, Brutal Humor
Etching on paper
30 x 22

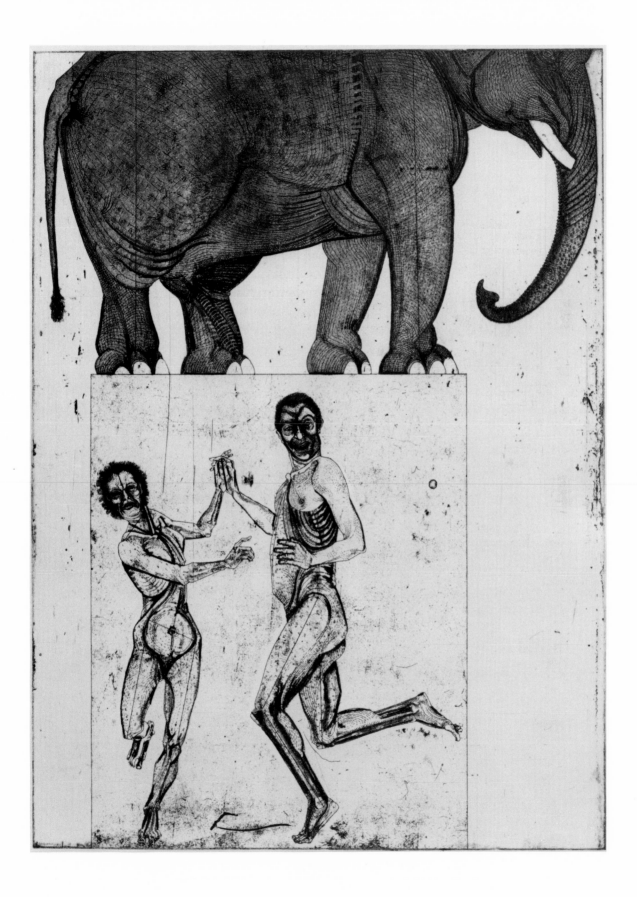

Yancey Robertson

Born Fayetteville, North Carolina,
1931; died 1984

B.A. 1953, Davidson College, Davidson, North Carolina; graduate
study 1954, Duke University;
Professional Diploma with Distinction 1958, School of the Boston
Museum of Fine Arts

Gold Medal, Petrarch Society of
Arts, Letters, and Sciences, Cortona, Italy, 1974; Silver Civic Medal, Cortona, Italy, 1973, 1974;
First Place, Piedmont Annual
Southeastern Painting and Sculpture Competition, Mint Museum
of Art, Charlotte, North Carolina,
1965; Honorable Mentions 1962,
1963, Third Place 1961, Second
Place 1960, *Springs Mills Annual
Exhibition*, Springs Mills, North
Carolina

Anyone familiar with Yancey Robertson's work knows that he
was fascinated with the classical and the grotesque elements of
Renaissance figure painting and sculpture. Examples fill the Italian environment in gardens, plazas, museums and other buildings. As a painter and draftsman, Robertson uniquely drew
upon these sources to refresh his personal vision. He became so
interested in the frescoes of Michelangelo, Mantenga, and others, admiring both the technique and the careful, contemplative
method of execution required by this medium, that he introduced fresco painting into his painting class.

Untitled 1982
Charcoal on paper
30 x 22
Collection of John N. Robertson II

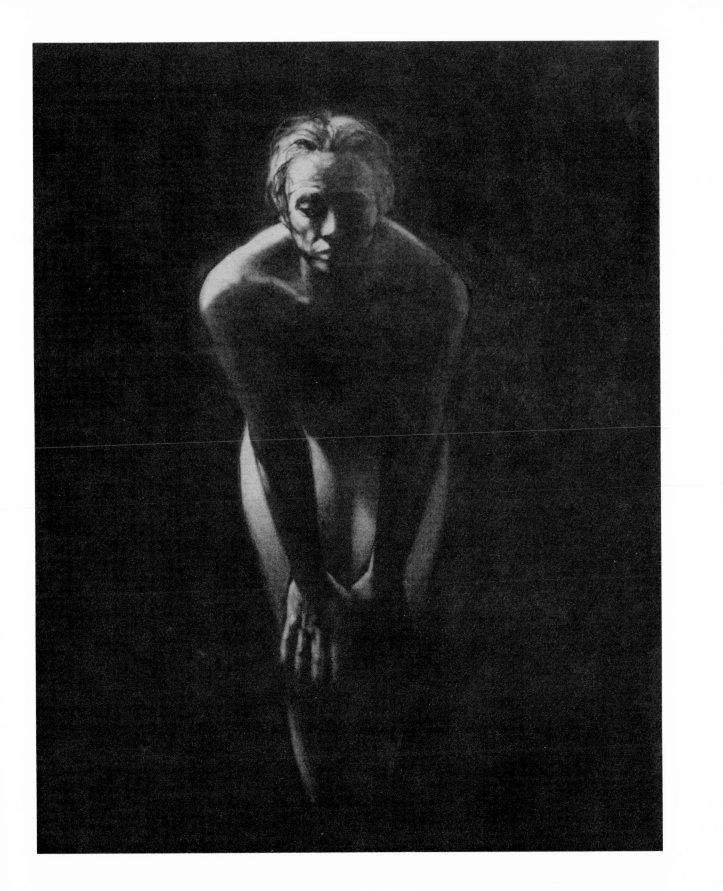

Art Rosenbaum

Born Ogdensburg, New York, 1938

B.F.A. 1960, M.F.A. 1961, Columbia University, New York City

Resides in Athens, Georgia; professor, Department of Art, The University of Georgia

Fulbright Grant for study in France, 1964-1965

Not an Expulsion in the Italian way; but the old preacher-artist points half in criticism, half in humor, beyond the ways of the flesh, while the blues singer, who knows about it all, sings. A Chianti bottle swings from the wall in Georgia as in Italy.

Beyond Chattooga 1988
Oil and alkyd resin on linen
28 x 36

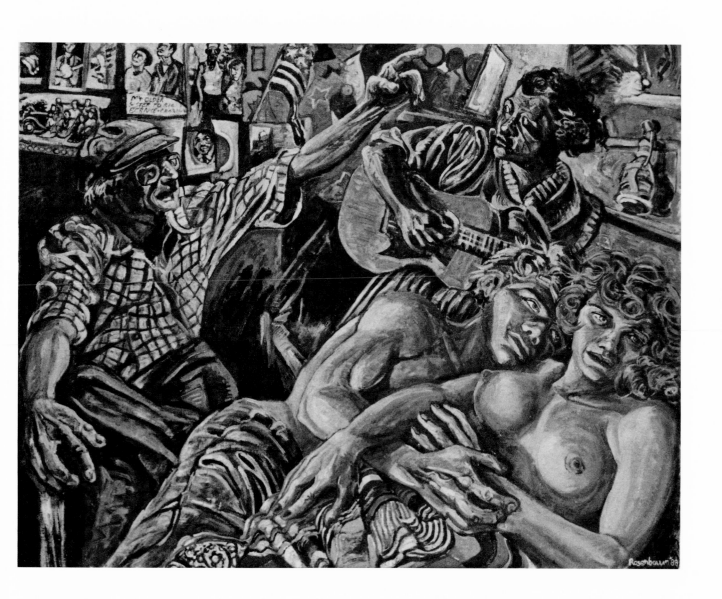

Conrad Ross

Born Chicago, Illinois, 1931

B.F.A. 1953, University of Illinois, Urbana-Champaign; M.F.A. 1959, University of Iowa, Iowa City

Resides in Auburn, Alabama; professor, Department of Art, Auburn University

Fellowship, Frans Masereel Center for Graphic Arts, Kasterlee, Belgium, 1986; Research Grants, Auburn University, Auburn, Alabama, 1965-1968; Louis Comfort Tiffany Foundation Grant, 1960

I was overwhelmed that summer of 1984 by the landscape. Perhaps it was the history of Cortona or perhaps it was the vast and airy spaces, but it was a productive summer when some notions of imagery came together and my work took a turn in a new direction.

Boone 1988
Lithograph, collagraph, and silkscreen on paper
25½ x 39

Boone 19/20 Conrad Ross '88

Wiley Sanderson

Born Detroit, Michigan, 1918

B.F.A. 1948, Wayne State University, Detroit, Michigan; M.F.A. 1949, Cranbrook Academy of Art, Bloomfield Hills, Michigan

Resides in Athens, Georgia; professor, Department of Art, The University of Georgia

Phot-Univers, Musée Francais de la Photographie, Paris, 1976; Bronze Medal, Europa '73, Reus, Spain, 1973

In preparation for my first of seven summers in Cortona, I designed and built four unique pinhole cameras. The challenge of these cameras and the inspiring beauty of Cortona caused a revolution in my way of seeing, in my photography, and in my style of living. Each research summer was a new revelation. The photographs that resulted have given me international recognition and have been collected by six European museums.

Surreal Palazzo 1974/1989
360° Pinhole camera photograph, Type C color print
13¾ x 48

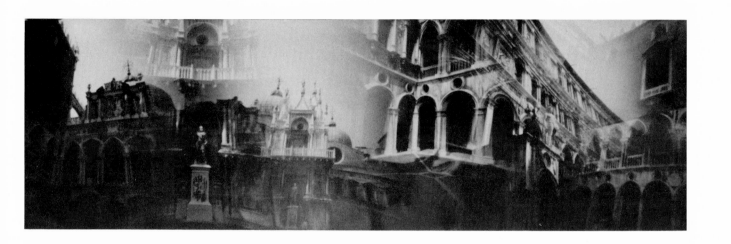

Ted Saupe

Born Orange, New Jersey, 1950

B.F.A. 1972, California College of
Arts and Crafts, Oakland; M.F.A.
1979, University of Wisconsin at
Madison

Resides in Knoxville, Tennessee;
associate professor, Department of
Art, University of Tennessee

SECCA/RJR Southeastern Artists
Fellowship, 1988

Lasting impressions include: dry colors, masonry architecture, contrasts in age, technology, and atmospheres. As a visitor I had the impression that all events, all places, and all common occurrences were taking place on-stage. I was fascinated and astounded every day I was in Italy.

Sister in the Desert 1988
Ceramic
21 x 12 x 26

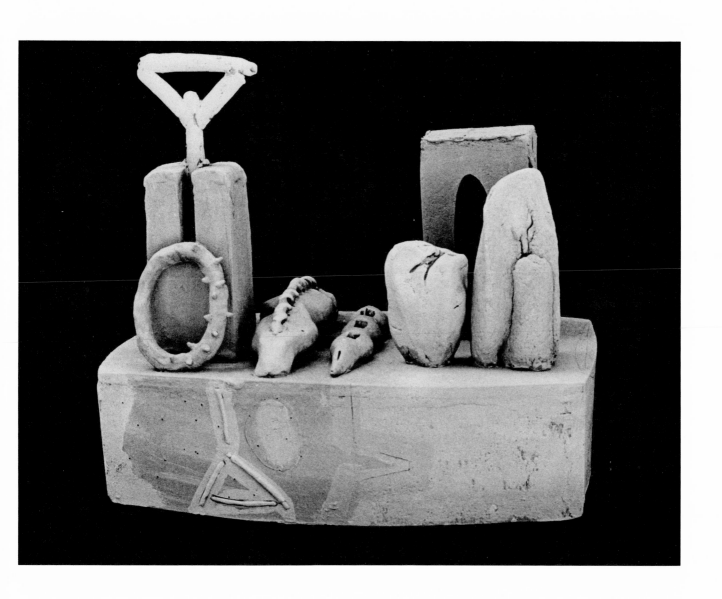

Floyd D. Shaman

Born Wheatland, Wyoming, 1935

B.A. 1968, M.A. 1969, University of Wyoming, Laramie

Resides in Cleveland, Mississippi; wood sculptor

First Place in Painting, Second Place in Sculpture, Vicksburg Competitive Show, Vicksburg, Mississippi, 1985; Second Place, *Fifth Annual Mississippi Competitive*, University of Southern Mississippi, Hattiesburg, Mississippi, 1983; Best-in-Show, Crosstie Festival, Cleveland, Mississippi, 1977; Fellowship, Yaddo, Saratoga Springs, New York, 1976; First Honorable Mention 1975; Award of Merit 1974, *Louisiana Festival of the Arts Exhibition*, Monroe, Louisiana, 1975; Del Mar College Purchase Award (First Place), *Del Mar College Seventh Annual Drawing and Small Sculpture Show*, Corpus Christi, Texas, 1973; Juror's Award and Brooks Art Gallery League Purchase Award, *17th Annual Mid-South Exhibition*, Memphis, Tennessee, 1972; First Honorable Mention and Cash Award, *21st Annual International Exhibition*, Beaumont, Texas, 1972

I would say to any young artist: Go to Cortona with Jack Kehoe—his joy and his love of Italy will rub off on you.

Manetta 1988
Wood, cloth, and plastic
78 x 37 x 24

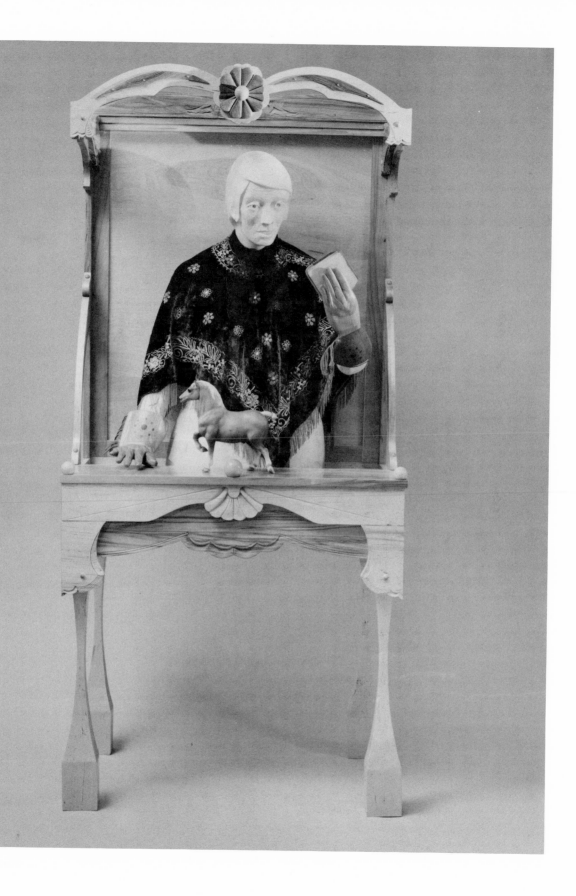

Sandy Simon

Born Minneapolis, Minnesota, 1949

Attended University of Minnesota

Resides in Berkeley, California; studio potter

National Endowment for the Arts Visual Artists Fellowship, 1988

What stimulated me was the presentation of consumer goods, especially the shoes. I bought many of them, and later began to see the fabric, the inserts, the color changes in my work. The ice cream was great, too.

Cup and Saucer 1988
Porcelain
4 x 5 x 3½

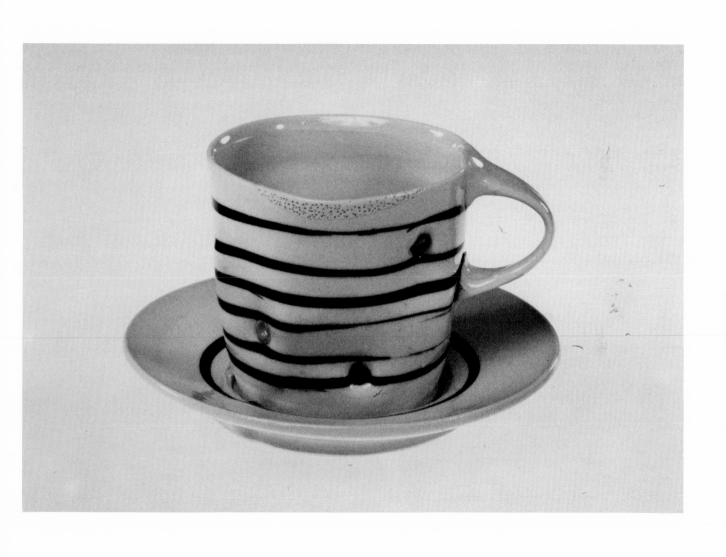

George Sorrels

Born Dallas, Texas, 1944

B.F.A. 1968, University of Texas at Austin; M.F.A. 1971, Cranbrook Academy of Art, Bloomfield Hills, Michigan

Resides in Kutztown, Pennsylvania; professor, Department of Fine Arts, Kutztown State University

National Endowment for the Arts, Artist-in-Residence Grant for The University of Georgia Studies Abroad Program, Cortona, 1979

When I think of Italy, I think of the first sight of Cortona in the sky; Raphael's *Transfiguration*; Mr. Banchelli's welcome gift of fresh strawberries; Fra Angelico's *Annunciation*; cool, romantic mornings; Botticelli's *Primavera*; afternoon coffee with Mrs. Ricci; Bellini's *Madonna of the Trees*; watching the evening trains in the valley below; Giorgone's *The Tempest*; Mr. Meoni's elegant letter; Leonardo's drawings; and the promise I made to myself to return someday.

Portrait of the Artist's Wife
Oil on canvas
5 x 7

Georgia Strange

Born Louisville, Kentucky, 1949

B.A. 1973, M.S. 1977, M.F.A. 1979, Indiana University, Bloomington

Resides in Bloomington, Indiana; assistant professor, School of Fine Arts, Indiana University

Indiana University Faculty Research Grants-in-Aid, 1987-88; Indiana Arts Commission Masters Fellowship, 1987; Ohio State University College of the Arts Research Grant, 1985; Ohio State University Small Research Grants, 1985; Centre College of Kentucky Faculty Summer Research Grants, 1980-1981; Ford Foundation Grant, Indiana University, 1979

Travel in Africa, Greece, and Italy has provided the greatest sustenance for me as an artist and as an American. Italy is the country to which I return at every opportunity. I have chosen Cortona for three summers and this summer will make my fourth visit. It's the sense of contemporary Italian culture thriving in an environment that pays homage to its history. The Cortona present is built on the layers of culture which have evolved from Etruscan times. I love that experience of the fullness of time.

Fundamental Exercise #2 1988
Wood, clay, formica, and linoleum
17 x 10 x 11

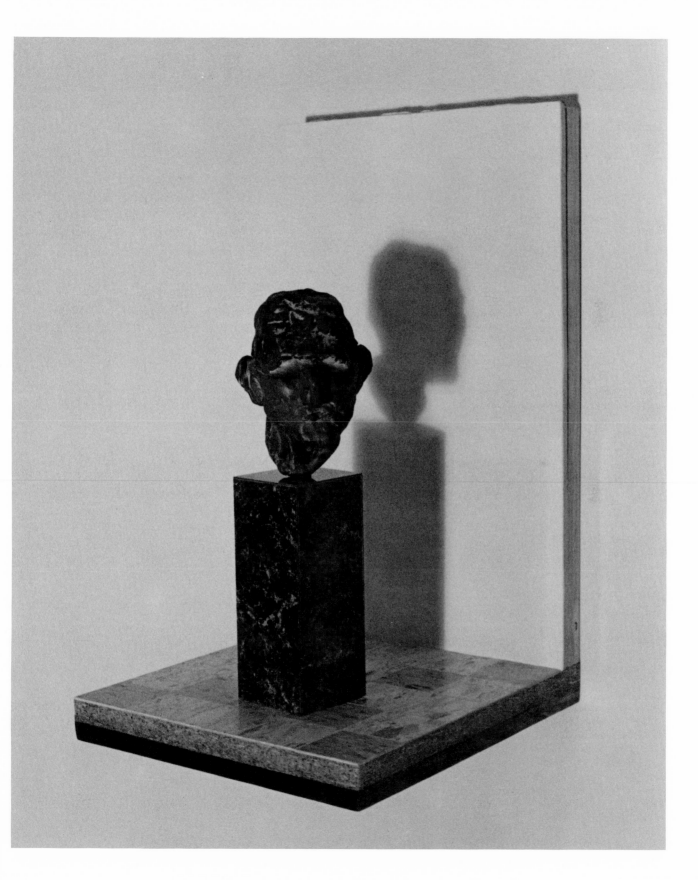

Joseph W. Strother

Born New Orleans, Louisiana, 1933

B.A. 1955, Louisiana College, Pineville; M.A. 1961, Ed.D. 1969, The University of Georgia, Athens

Resides in Ruston, Louisiana; director, School of Art and Architecture, Louisiana Tech University

First Purchase Award, *Fifteenth Annual Arts Festival*, Alexandria, Louisiana, 1981; Cash Award, *Eleventh Annual Arts Festival*, Alexandria, Louisiana, 1977; Cash Award, *Central South Exhibition*, The Parthenon, Nashville, Tennessee, 1976; Athena Award, *Central South Exhibition*, The Parthenon, Nashville, Tennessee, 1975; M. G. Michael Award, Franklin College of Arts and Sciences, The University of Georgia, Athens, 1973; First Purchase Award, *Seventh Annual School of Mental Health Exhibition*, University of North Carolina, Chapel Hill, 1971

In fifty-four years, I've visited and lived in twenty countries, including ten years spent in China. Yet when beauty, the joy of living, the exuberance of producing, and the richness of cross-cultural human experience come to mind, Cortona instantly and clearly emerges from memory. All of my senses—visual, physical, psychic—were totally activated in that ancient arena of art, love, war, and learning. And Cortonese hospitality and food remain unsurpassed in my travels. We are the cumulative summation of our experiences yet in ordering these by rank (for they truly are not and cannot be the same), my Cortona months, though short, impacted greatly upon who I am. I am an American by birth and love my country. If adopted, however, I could willingly become an Italian as I still feel the pull of Tuscany and that magnetic Etruscan city on the hill: Cortona.

Cypress Series #4 1985
Acrylic on canvas
36 x 36

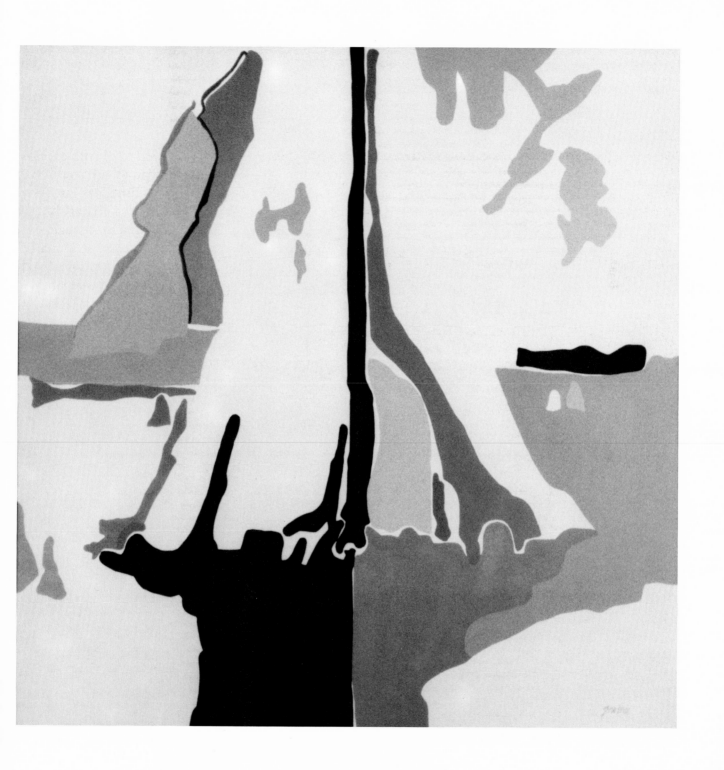

Ira M. Taylor

Born Hot Springs, Arkansas, 1935

B.S. 1968, Arkansas Tech University, Russellville; M.A. 1970, M.F.A. 1973, Louisiana State University, Baton Rouge

Resides in Abilene, Texas; chairman and professor, Department of Art, Hardin-Simmons University

I love color, texture, shapes, shiny metal, stone, wood, form, and imagination, and I am devoted to making prints and sculpture that people can enjoy. When I begin each piece, I approach it with a bit of whimsy or wonder or nostalgia and occasionally my beliefs about God, life, nature, and love creep into the work. I believe art is to be enjoyed and I believe the person that makes art should enjoy it as much, maybe more, than the person that finally owns it. I do.

Living with the great art of the past and working with fine artists of the present have added a facet to my artistic life that will remain a viable part of my art. Italy changes you but Cortona welds that change into the very fabric of your being. To carve, is for me, to experience Cortona once again.

Mother and Child 1987
Marble
23 x 11½ x 7

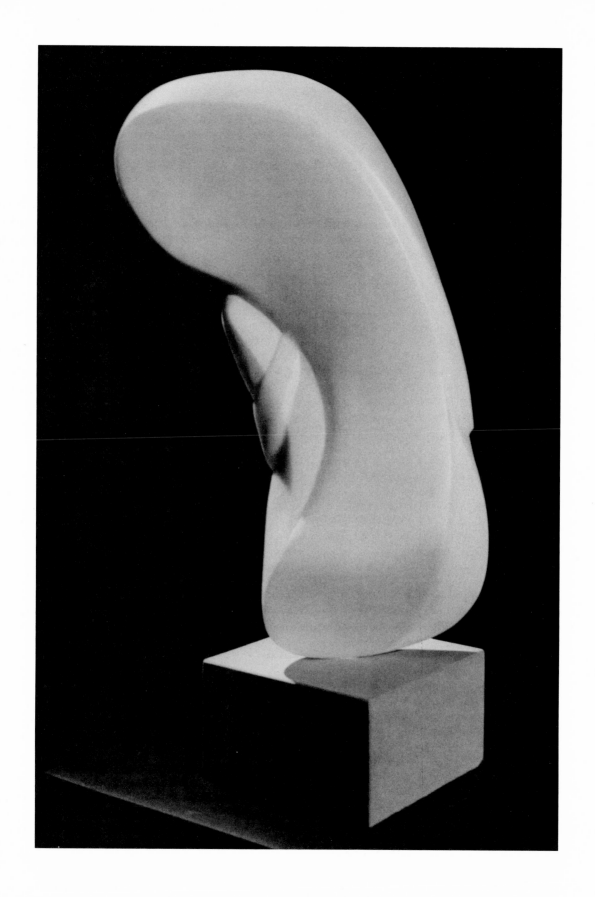

Larry Thomas

Born Washington, D.C., 1939

B.A. 1966, LaGrange College, LaGrange, Georgia; M.F.A. 1969, The University of Georgia, Athens

Resides in Atlanta, Georgia; associate professor, School of Art and Design, Georgia State University

MacDowell Colony Residency, 1974-1975; Printer Fellowship, Tamarind Lithography Workshop, 1969-1970

On March 15, I put out the last of the basil seeds—seeds I had rationed to last three seasons. The man who sold them to me made me guess his age. Then he called me "Professore" and meant it. I liked that! I really liked that. If you are in Cortona as you read this, will you go up to the porch of the theatre and buy me some more seeds? The old man won't remember, but I do.

This Meal Does Not Contain Pork 1987
Mixed media
4 x 7½ x ¾

Richard Tichich

Born Minneapolis, Minnesota, 1947

B.A. 1969, Saint John's University, Collegeville, Minnesota; M.A. 1970, The University of Iowa, Iowa City; M.F.A. 1979, University of Texas at San Antonio

Resides in Statesboro, Georgia; chairman, Department of Art, Georgia Southern College

Charles McDaniel Memorial Award for Excellence in Art Education, Georgia Southern College, Statesboro, 1986

During the summer of 1987 I was a visiting artist at The University of Georgia Cortona Studies Abroad Program.

During my stay in Cortona I produced a series of photographs featuring the clergy that served the city and the surrounding communities. The total series is comprised of twenty five portraits with a range from the extremely small parish of San Pietro a Dame to the Bishop of Arezzo. No mention of the total effort would be complete without a special thanks to Don Bruno Frescucci, who provided valuable assistance.

Cortona 1987
Gelatin silver print
16 x 17

Jim Touchton

Born Hahira, Georgia, 1952

B.F.A. 1975, Valdosta State College, Valdosta, Georgia; M.F.A. 1977, The University of Georgia, Athens

Resides in New York City; artist

Cortona has had a profound influence on my work as a painterly realist. The experience was my first total immersion in a complete, artistic and cultural environment. The panoramic setting and the natural beauty of this hilltop Tuscan village combined with the warmth of its residents were exciting inspiration for my art. Before Cortona, my work consisted of a figurative orientation. During my stay there, both my interest and love of landscapes surfaced and began what was eventually to become one of the primary forces in my painting. Indeed, my current work has deep roots in the Cortona experience.

View Over Secret Harbor 1987
Oil on canvas
60 x 72
Courtesy Fischbach Gallery, New York City

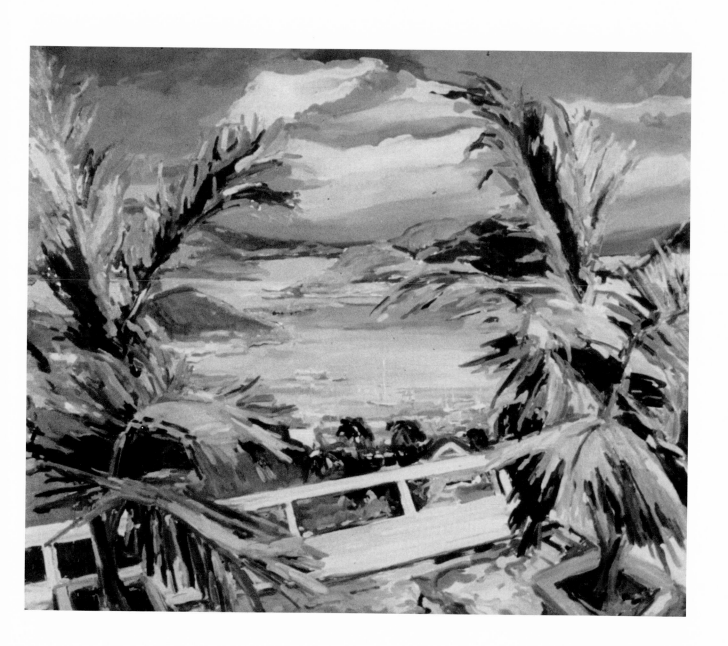

Richard Upton

Born Hartford, Connecticut

B.F.A. 1960, University of Connecticut, Storrs; M.F.A. 1963, Indiana University, Bloomington

Resides in Saratoga Springs, New York; professor, Department of Art, Skidmore College

Artists for Environment Foundation/NEA, 1972-1973; Fulbright Grant, Paris, 1964-1965

Value in painting is a function of those issues raised and the consequent responses proposed. Abstract pictorial light, the architectonics of color, light, form (structure)—metaphysically centered—is the language of these (Italy) paintings. Painting the landscape is also a way to understand my own "Nature."

Since 1982 the (Italian) landscape has figured preeminently in this quest in part due to the rich artistic and cultural heritage Italy has offered (the world) and, most especially, because my mother and her parents before her were born there and infused my childhood with the sensibilities of "Italian life."

Cortona and the Val di Chiana have been for me what Mt. Sainte-Victoire was for Cezanne—pulsing with those "little sensations" from deep down within the innermost life. It has been a treasured place to work without intrusion for these past six years and I am most pleased to give back in a small way my heartfelt thanks to the peoples of Cortona.

Val di Chiana/La Sacra Conversazione 1987-1988
Mixed media on paper
16 x 23
(detail)
Courtesy Everson Museum of Art

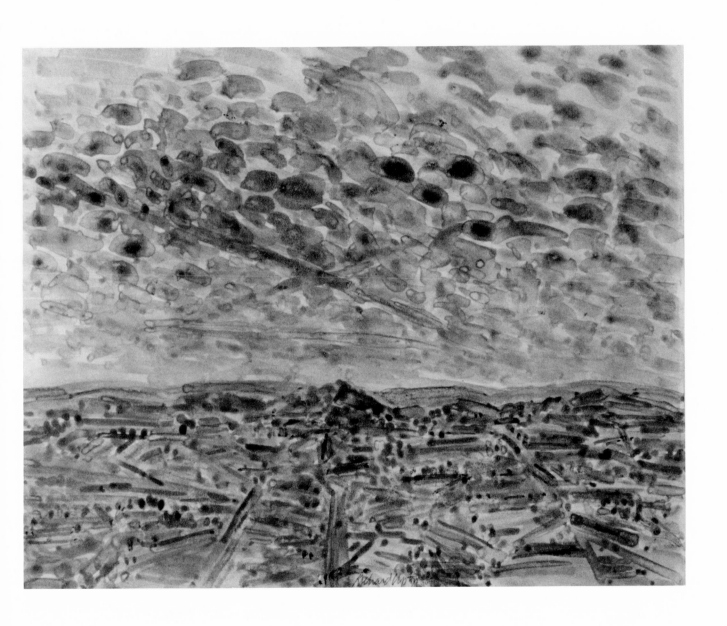

Tony Vevers

Born London, England, 1926

B.A. 1950, Yale University; Accademia di Belle Arti, Florence, 1950-1951; Hans Hofmann School, New York City, 1952-1953

Resides in Provincetown, Massachusetts; professor emeritus, Department of Creative Arts, Purdue University, Lafayette, Indiana

Sponsor's prize, *23rd Annual Exhibition*, Hunterdon Art Center, Clinton, New Jersey, 1976; Best of Show Award, *Sugar Creek Biannual Exhibition*, Crawfordsville, Indiana, 1974; Prize, *New England Painting and Sculpture Exhibition*, Provincetown Art Association, Provincetown, Massachusetts, 1971; XL Grant, Purdue University, 1970; National Council on Art and Humanities Grant, 1967; Walter Gutman Foundation Grant, 1961

As a young artist I found myself through work and study in Italy during 1950-1952. It was therefore a great experience to come back to Italy as a teacher, in the first fall program of The University of Georgia at Cortona in 1984. Now, to exhibit a work of my maturity in a show dedicated to the students and teachers of the program and to the people of Cortona is to come to a completion of the cycle. Mille grazie!

Iphigenia II 1987
Mixed media on paper on canvas
32½ x 40½

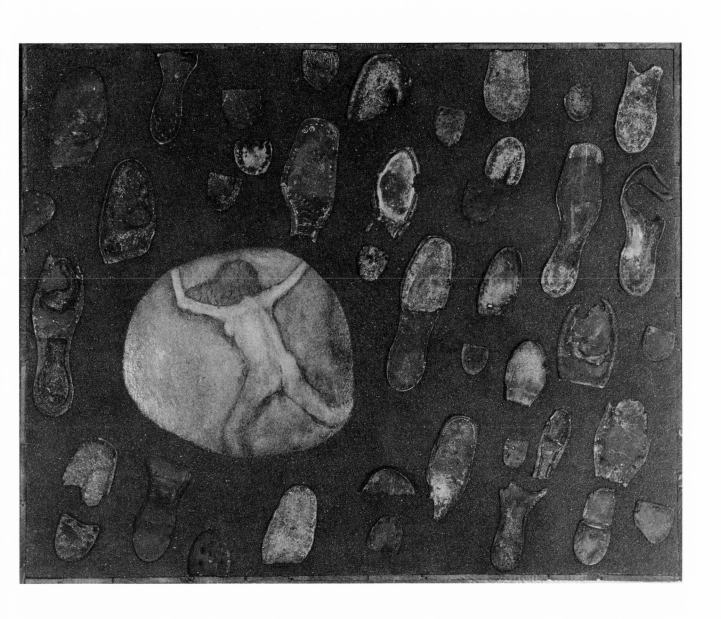

Virginia Wright-Frierson

Born Washington, D.C., 1949

B.F.A. 1971, University of North Carolina at Greensboro; Art Students League, New York City, 1969; The University of Georgia Studies Abroad Program, Cortona, Italy, 1971; University of Arizona, Tucson, 1973-1976

Resides in Wilmington, North Carolina; instructor, St. John's Museum of Art

Purchase Award, St. John's Museum of Art, Wilmington, North Carolina, 1982

I participated in the Studies Abroad Program in Cortona in 1971. My experience there marked the transition between my student and professional life. I was greatly influenced by the excellent teachers in the program and by the beautiful and inspiring setting, painting many studies of the landscape, architecture, streets, and flowers of Italy that summer. I have continued to work from life for the last seventeen years and have always dreamed of returning to Cortona with my family. I hope to be an artist-in-residence for the summer of 1989.

Wild Poppies 1983
Watercolor on paper
17 x 17

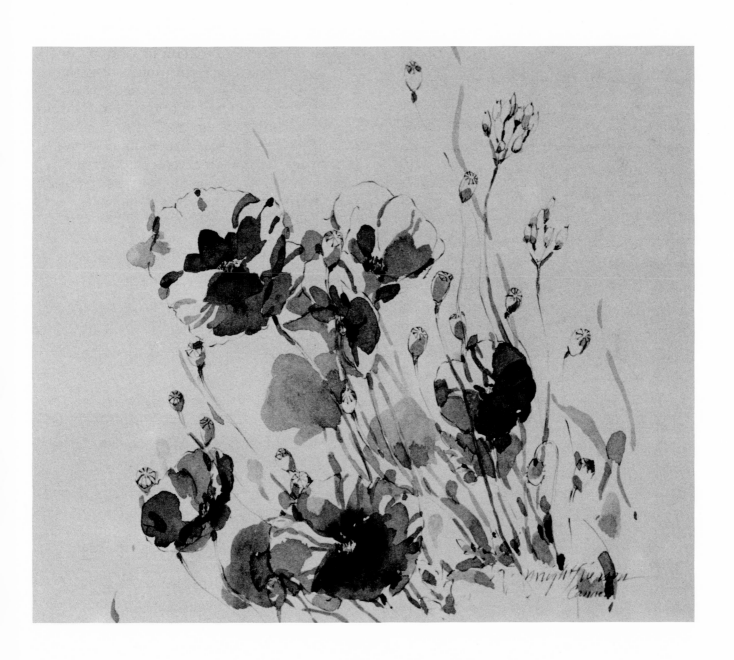

The University of Georgia Studies Abroad Program

Staff

John D. Kehoe
director and founder

Aurelia Ghezzi
assistant director and program coordinator

Marion Bowden
administrative secretary

Sue Roach
accountant

Christopher Jones, Pamela Bobe, and Lara Johnson
student assistants

Sylvia Pisani
20th anniversary show coordinator

Twentieth Anniversary Board of Directors

Lamar Dodd
Marchese Emilio Pucci
honorary chairmen

Mrs. Ann Barton
Dr. and Mrs. William Benson
Mr. Sergio S. Dolfi
Mr. Michael Erlanger
Mrs. Arthur Fickling
Mr. John Fornara
Mr. John D. Kehoe
Mrs. Shell Knox
Mrs. Betsy Leebern
Mr. David Lester
Mr. and Mrs. John McMullen
Mr. Alex Patterson
Dr. and Mrs. Henry Randall
Mrs. Betty Sanders
Dr. Barbara Shaw
Mrs. Betty Smith
Mrs. Pat Terwilliger